The **Kodak** Most Basic Book of Digital Printing

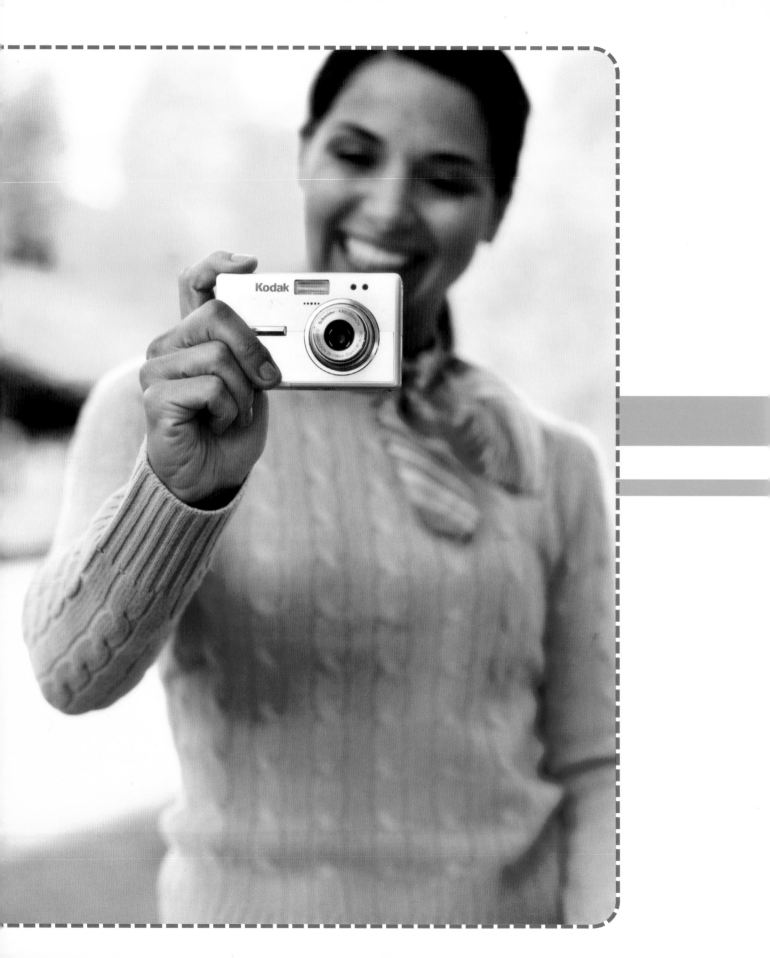

The **Kodak** Most Basic Book of Digital Printing

Jenni Bidner

Kodak Books

Published by Lark Books
A Division of Sterling Publishing Co., Inc.
New York

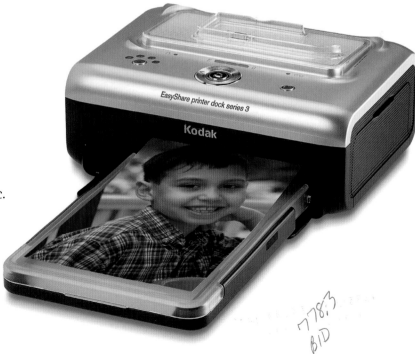

Editor: Haley Pritchard
Book Design and Layout: Tom Metcalf
Cover Designer: Thom Gaines
Associate Art Director: Shannon Yokeley
Editorial Assistance: Delores Gosnell
Illustrator: Orrin Lundgren

Library of Congress Cataloging-in-Publication Data

Bidner, Jenni.
 The Kodak most basic book of digital printing / Jenni Bidner.— 1st ed.
 p. cm.
 Includes index.
 ISBN 1-57990-777-6 (pbk.)
 1. Photography—Digital techniques. 2. Digital printing. I. Eastman Kodak
Company. II. Title: The Kodak most basic book of digital printing. III. Title.
TR267.B548 2006
775—dc22

 2005018012

10 9 8 7 6 5 4 3 2 1

First Edition

Published by Lark Books, A Division of
Sterling Publishing Co., Inc.
387 Park Avenue South, New York, N.Y. 10016

© 2006, Eastman Kodak Company
Photography © Eastman Kodak Company unless otherwise specified
Product images on pages 52-53 are © their respective manufacturers
Illustrations © 2006, Lark Books unless otherwise specified

Distributed in Canada by Sterling Publishing,
c/o Canadian Manda Group, 165 Dufferin Street
Toronto, Ontario, Canada M6K 3H6

Cover photos © Nancy Brown: Two little girls, © Robert Ganz: Lion boy, © Dan Heller: Blue lake with boats,
Horseshoe bend (upper left corner), © Joseph Meehan: Sunset boats
Back cover photos © Jenni Bidner, Illustrations © Lark Books

Distributed in the United Kingdom by GMC Distribution Services,
Castle Place, 166 High Street, Lewes, East Sussex, England BN7 1XU

Distributed in Australia by Capricorn Link (Australia) Pty Ltd.,
P.O. Box 704, Windsor, NSW 2756 Australia

If you have questions or comments about this book, please contact:
Lark Books, 67 Broadway, Asheville, NC 28801, (828) 253-0467

Manufactured in China

ISBN 13: 978-1-57990-777-8
ISBN 10: 1-57990-777-6

For information about custom editions, special sales, premium and corporate purchases, please contact Sterling Special Sales Department at 800-805-5489
or specialsales@sterlingpub.com.

contents

Introduction to Digital Basics

Congratulations! By opening this book you've taken your first step into the world of digital printing. Before we dive into the actual printing section of this book, it is imperative that you understand the basic concept of digital photography. The best thing about digital photography is that you no longer have to learn the "ancient" art of darkroom techniques and sit in a chemical-filled closet for hours to print at home. Making great prints of your film and digital pictures is easy once you know a few basic ground rules. The initial approach to digital printing comes in two forms: You can start with a digital camera and print the pictures it takes, or you can convert your film, prints, and artwork into digital pictures using a scanner, then print them.

Even those of you on the cutting edge of digital photography will fall into both categories from time to time if you have a collection of photos from your film days. The chapter that begins on page 12 will help you to turn these photographs into digital images so you can use them in your creative printing projects.

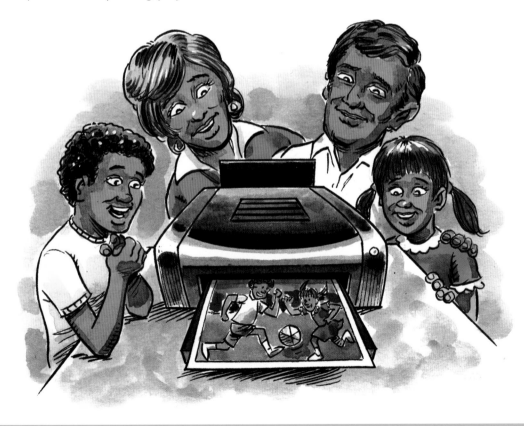

"Learning how to print is more about understanding digital photography than anything else."

What Is a Digital Picture?

The easiest way to think of a digital photograph is as a big jigsaw puzzle. But, instead of puzzle pieces, it's made up of pixels. Each pixel holds a little piece of the picture on it, just like a single jigsaw piece. All by itself, an individual pixel doesn't seem to have any meaning. But when they're all lined up and in the right place, they create a whole picture! The more pieces (pixels) that you have, the bigger the "jigsaw" picture can be. A camera that uses one million individual pixels to create a picture is called a 1-megapixel camera. A 5-megapixel camera uses five million pixels.

Image resolution is determined by the number of pixels used to make the picture. High-resolution images have more pixels, while low-resolution images have fewer. Because a high-resolution picture has more pixels (more "puzzle pieces"), it takes up more space in the camera and on the computer when you save it—this space is called memory. The more memory an image takes up, the higher its file size. In other words, a high-resolution image will have a larger file size than a low-resolution image.

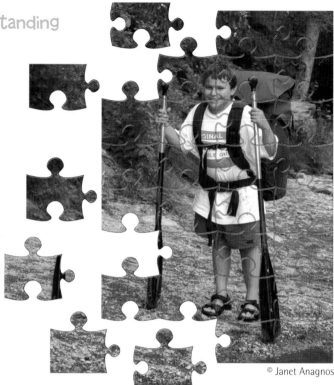

© Janet Anagnos

A digital picture is made up of a lot of small picture elements, called pixels. This is not dissimilar to the way a jigsaw puzzle is made up of small pieces, each with a tiny bit of information, which fit together to make a complete picture.

"In the old days, you needed a lot of chemicals, knowledge, and time to create prints in a darkroom. The modern 'digital darkroom' can be as easy as a click of the mouse or the press of a button."

The resolution of this picture of me is too low, therefore it doesn't print very well.

High-resolution images can be printed larger than low-resolution images can. If a picture is printed at a size that is larger than its resolution allows, it will appear soft, choppy, or "grainy," like the picture on the right.

Image resolution can be expressed in three ways:

• A total number, such as 2.16 megapixels, or 2,160,000 pixels.

• A mathematical expression of pixel dimensions (i.e., a certain number of pixels wide by a certain number of pixels long, such as 1200 x 1800. If you do the math, 1200 x 1800 = 2,160,000 pixels, or 2.16 megapixels.

• A print size in conjunction with a certain resolution, such as 4 x 6 inches (A6) at 300 ppi. Since 300 x 4 = 1200, and 300 x 6 = 1800, this is also a 2.16 megapixel image.

Image Resolution

Before you begin printing it is important to understand how the image resolution of your digital picture affects the quality of your print. Image resolution refers to the number of pixels that make up the image. This affects how large you can make your print before it starts breaking up and getting less clear. Technically, image resolution is described in terms of ppi (pixels per inch) and printer resolution is usually measured in dpi (dots per inch).

Unfortunately, most people in the world of digital photography, often including manufacturers, use these two terms interchangeably. So, in modern lingo, dpi and ppi are indistinguishable. (See page 41 for more about resolution.)

This picture has a higher resolution, so it looks great!

Starting with a Film Camera

© Canon, Inc.

"You need to 'digitize' your film-based pictures, slides, or negatives to enter them into the world of at-home digital printing, emailing, and more."

Don't worry! You're not "out of the loop" if you're still using a camera that shoots film. There are plenty of advantages to shooting film. For starters, you don't have to buy a new camera when your old one still works fine and you already know how to use it. Sure, you still have to take your film to the lab to have it processed and printed, but today, it's easy to convert prints into digital photographs, as well.

Even if you have embraced digital whole-heartedly and your old film camera is gaining a thick layer of dust, you probably have stacks of wonderful images (both negatives and prints) of days gone by. It's easy to convert traditional photographs made with film cameras into digital pictures that can be improved with image-processing software, shared through email and on the web, printed at home, and turned into fantastic gifts like calendars and bound books.

© Mimi Netzel

> "A digital photo is made up of lots of tiny pixels, which is short for picture elements."

Digitizing Your Prints and Film

In order to get your old film pictures into the computer, or send them to your desktop printer, you need to digitize them. "Digitize" is a fancy word that means turning a print or negative into a computer file. A digital picture is a computer file that tells your computer software what the photograph should look like. This file can then be printed to create a photographic print.

How does the computer file do this? It builds the picture by putting together tiny picture elements known as pixels. These pixels each hold a small amount of information about the picture. When joined together like pieces in a puzzle, they create the whole image. The more pixels used to make the picture, the better the quality and the higher the resolution of the digital image. (See page 41 for more details on resolution).

Four Ways to Digitize

In order to create a digital version of a print, negative, or slide, it must be scanned. The scanning process converts the hard copy (the photographic print or film) into a computerized digital picture file.

There are five basic ways to convert your traditional photographs into digital pictures:

1 **Flatbed Scanners:** One of the quickest and least expensive ways to digitize your conventional photographs is to do it yourself using a flatbed scanner. Most flatbed scanners look like the top portion of a photocopier machine—you lift the lid and place the print face down on the glass. Low-priced models are available, and you can quickly and easily get good scanning results right out of the box. Simply attach the scanner to your computer via the cord that came with it (or use a wireless connection, available with some scanners), then install the software. In short order, you're ready to start digitizing your prints.

A flatbed scanner has a glass top similar to a photocopier machine. You lay your print or artwork face-down, close the cover, and scan.

You can scan a lot more than just photographic prints with a flatbed scanner. Don't overlook your children's artwork, or memorabilia such as ticket stubs, report cards, merit badges, 1st Place ribbons, and more.

© Kate Bie

Creative Scanning

© Jenni Bidner

Flatbed scanners can be used for more than just prints. You can scan any relatively flat objects. If you're careful not to scratch the glass, you can also scan 3D objects, such as fresh flowers or stuffed animals to make two-dimensional pictures of them. If you leave the cover open, you will get a lighter background. For a dark or colored background, drape a black or colored cloth over the items. If your objects are hard, moist, or have sharp edges, first lay a piece of clear acetate (such as blank overhead transparency material) on the glass to form a protective layer, and then position your objects.

2 **Film Scanners:** Film scanners (also called transparency scanners) are designed to shine light through a piece of film to copy slides and negatives during the scanning process. Often, they have film holders of different sizes to accommodate strips of negatives. To scan film, you need a relatively high-resolution scanner because most film is fairly small. For example, a 35mm film negative is only 1 x 1.5 inches (26 x 37 mm) in size, so it needs to be enlarged four times or more just to make a 4 x 6-inch print (A6).

A film scanner digitizes film (i.e., negatives, transparencies, and slides) by shining light through the film and recording the resulting image.

3 **All-In-One-Scanners:** Some scanners function as a flatbed scanner, film scanner, photocopy machine, and a printer all in one! As with any "do-it-all" machine, check that each individual capability is of a high enough quality to be worthwhile. If you don't need all these extra capabilities in one machine, you might be better off just buying a dedicated flatbed or film scanner. (Keep in mind that some flatbed scanners can also scan film, so you do have the option of getting a multi-purpose scanner without investing in an all-in-one machine.)

4 **Stores and Labs:** If you don't want to scan older prints and negatives yourself, or if you only have a few images to scan, you can consider having them done by a store or lab. Many offer *Kodak* Picture CD services. Simply request a *Kodak* Picture CD when you bring your film in for processing and you'll get back an envelope with your negatives, your prints, and a CD with a digital version of each picture on the roll! Some labs will also take a stack of your older prints and negatives and make a CD of them for you.

5 ***Kodak* Picture Maker Kiosks:** Found at many malls and stores, *Kodak* Picture Maker kiosks enable you to scan prints, make simple edits, and print them as traditional prints or as creative novelties like calendars or cards.

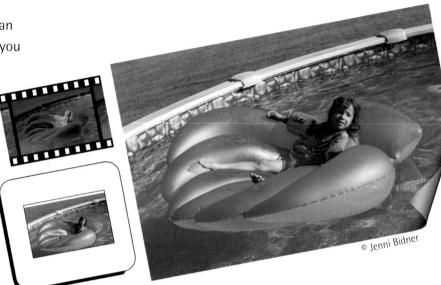

© Jenni Bidner

Your original film is much smaller than your prints. If you start with film, you will have to enlarge it to four or more times its actual size in order to make a print. To make a quality reproduction, you'll need to use a film scanner with at least 2400 ppi of resolution capability. (This is higher than the minimum of 1200 ppi if you're scanning prints on a flatbed scanner.)

***Kodak* Picture CD processing services and *Kodak* Picture Maker kiosks are great options for digitizing your film and prints.**

Scanning Your Pictures

If you decide to scan your own pictures, you'll need to learn a few scanning basics. First, you'll need to understand the part that resolution plays in the scanning process. The resolution at which you scan your picture will determine the quality of the digital image that results from the scan. This digital image then determines how large (and at what quality) you can make a print of that picture. Basically, the higher the resolution a scanner is capable of, the bigger the prints you will be able to make from your scanned pictures.

Typical resolutions for flatbed scanners are between 1200 and 4800 ppi (pixels per inch). The more pixels your scanner can record per inch, the higher the resolution of your scanned image will be. A 1200 ppi flatbed scanner is usually adequate

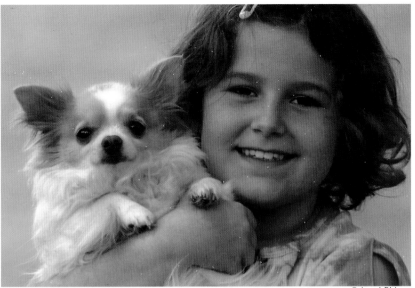

© Jenni Bidner

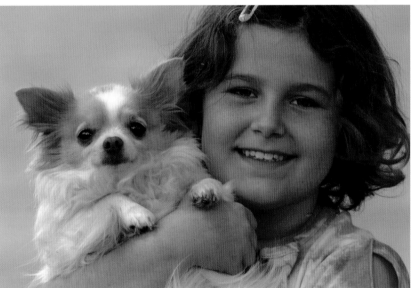

for most home users who will be scanning 4 x 6-inch prints (A6) and making 8 x 10 or 8 x 12-inch prints (A4). Jumping up to 2400 ppi will cover your bases, though, if you are starting with smaller prints, planning to crop out a portion of the original photo, or making bigger enlargements. Film scanners are another story because standard 35mm film must be enlarged to four times its size just to make a 4 x 6-inch print (A6). Therefore, you'll want a film scanner with a resolution capability of 2400 ppi or greater. (For more about ppi and image resolution, see page 41.)

A scan of a dirty or damaged negative could be marred by white and black marks (like the top original scan of the image) unless your scanner has automatic correction software (see the dust-corrected image on the bottom).

The original film negative or slide has more detail and tone than the print made from it. So, in a perfect world, it's usually better to scan the negative or slide than the print. And certainly, if you have professional photography aspirations, or always demand the maximum in quality regardless of the cost and learning curve, you'll want to scan your original negatives and slides. In this case, you'll want to invest in a dedicated film scanner. For most people, however,

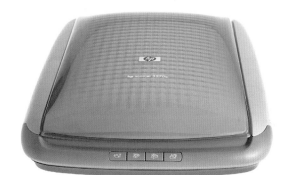

© Hewlett-Packard Development Company, L.P.

the quality difference between scanning a print (which is easy) and scanning the original film negative or slide (which is harder and more expensive) will be negligible, especially when you consider these factors:

• Sorting through negatives can make it difficult to find the exact image you want to scan.

• Negatives and slides are fragile and easily damaged, so they must be handled very carefully.
Negatives and slides are "dust magnets" so, invariably, your scans of them will be marred with dust specs (small black or white marks) unless extra care is taken in cleaning them, or the scanner software automatically removes these marks. Manually correcting dust spots using image-processing software can be a time-consuming process!

• A scanner with film scanning capability usually costs more than a flatbed print scanner.

• Since standard 35mm film is only about 1 x 1.5 inches (26 x 37 mm), it needs to be enlarged four times or more to make a print. Therefore, a relatively high resolution film scanner is needed, such as 2400 ppi or 4800 ppi.

• If you only have a few negatives or slides you want to digitize, it might be more cost effective and less of a hassle to buy a flatbed scanner for the prints and take the film to a lab or store.

Note: Before you begin the scanning process, you should create a folder on your computer's desktop where you will save the images you scan. That way, you'll always know where to look when you turn on your computer and want to find your images.

Using Your Scanner

Most of today's scanners offer "plug-and-play" simplicity. You take it out of the box, connect it to your computer, run the software CD that is included, and you're ready to start scanning. Usually a scan window opens on your computer to walk you through the process. Most scanner software provides controls for cropping and sizing your scanned images. Some software also lets you adjust the color and contrast in the photo. Once you've scanned an image, it will pop up on your computer fairly quickly. When it does, use your computer's Save control to store the image you've created. Now you have a digital version of your photo!

Note: It is always a good idea to save your image right after it appears on your computer screen. Give it a name that you will recognize later, and save it just as it is to the folder you've created before making any changes (i.e., before cropping, sizing, or adjusting the picture's color, or contrast). This way, if you later decide that you don't like the way your changes turned out, you can always go back to the original image and start over without having to go through the scanning process again.

There are some scanners that require that the scan be initiated through image-processing software. In this case, you'll need to import the scanner into the program. This is often as simple as going to the File menu and selecting Import. Then select the name of your scanner. The instruction manual that came with the scanner will describe the process in detail, and most people are up and running in a matter of minutes.

Ten Steps to Great Flatbed Scans

When you first start scanning your pictures, there may be some trial and error involved. However, if you follow these ten tips, you should get very good results, even on the first few tries!

© Jenni Bidner

1 **Keep the Glass Clean:** Fingerprints, dust, hairs, glue, and other substances will all show up in your finished digital picture. If you're skilled with photo-retouching software, you can some-times clean them up later, but why waste the time if a few seconds of housekeeping can avoid the problem in the first place?

2 **Click on Preview:** Most scanners automatically do a pre-scan that quickly scans the entire glass surface. If yours doesn't, manually click on the Preview button. This is similar to the way you can preview a Microsoft Word document to see how your text looks on the page before printing it.

3 **Check the Alignment:** Once the image has been previewed, check the alignment. If it is crooked, you can straighten it now to save time retouch-ing it later.

4 **Be Sure the Crop Is Correct:** Most scanners automatically crop to the size of the image on the glass. Use the preview to make sure it is correct. This is especially important if you have placed two or three small prints on the glass of the scanner at the same time and want to scan them as three separate digital picture files.

5 **Select the Scanning Mode or Format:** Most scanners give you several different scanning modes based on what you are scanning. Choices often include Black-and-White (which actually refers to line art, like text, a pencil drawing, or a signature), Grayscale (which is what most of us call a "black-and-white" photo), Color Document (like a ticket stub, or a colored draw-ing), and Color Photo. For the best scan results, select the mode or format that is most appro-priate for what you're scanning.

6 **Select the Resolution or Scan Size:** How "big" the scanner will make your digital picture is determined by a combination of the resolution you scan the picture at and the image size you choose. For resolution suggestions, see the chart on page 20. For image size, select the size you plan to print at (like 8 x 10 inches—A4—for example), or choose an enlargement percentage (i.e., to double the size of your scanned print, you would scan at 200%). But watch out! Higher resolutions and larger image sizes create digital pictures with larger file sizes. A large file can eat up a lot of memory on your computer and take a long time to open or save. If you have an older, less powerful computer, it could crash and you'd need to start over.

7 **Make Corrections:** A few high-end scanners allow you to use the Preview feature (refer back to number 2) to make adjustments to the image using controls such as Brightness, Contrast, Color, and more, before you scan. This extra step can save time later since it often eliminates the need for post-scan corrections (see number 10, below).

8 **Initiate the Scan:** Click on "Scan," or press the Scan button and the scanner will go to work. Depending on the particular scanner you're using and the settings you've selected, scanning time can range from seconds to minutes. Resist the temptation to lift the lid and check on the progress! If you interrupt the scanning process, you may have to start all over.

9 **Save the Picture:** When the scan is done, your new digital picture file will pop up on the monitor. At this point, you'll need to save the picture. Refer to pages 32-37 for suggestions on good file names and how to set up an image "library."

10 **Post-Scan Corrections:** Depending on the quality of your original prints and the capabilities of the scanner you used to scan them, you may or may not need to make a few post-scan improvements to your new digital picture. Some very simple corrections can create vast improvements to your digital pictures in a matter of seconds. (See pages 76-89 for more information.)

Scanning Resolution

What resolution should I pick when scanning my prints?

Output	Resolution (dpi)	Additional Information
Email or Website	75 or 100	A computer monitor requires less resolution to display a photo than your printer.
Inkjet Printer	250 to 300	Prints made by labs on traditional photo paper look best at resolutions of 250 and higher.

Hint:
If you like the warm tone of an old black-and-white photograph, scan it in Color Photo mode (rather than Grayscale). This will yield a larger file size, but it will keep the sepia or reddish tint to the image.

Don't Break the Law!

Some scanners have software that allows you to place multiple small prints on the glass at the same time. The scanner then automatically senses the different picture borders and scans them as separate files. This feature can be a great time saver, so look for it if you are planning to do a lot of scanning.

Photo courtesy of Jenni Bidner

Many historic photos have a nice, aged tone to them. If you want to keep this tone in your scan, you should use the Color Photo scanning mode, as with the top photo. If you scan old "black-and-white" photos in Grayscale mode, the resulting digital images will be "true" black-and-white, with no color tones, as in the image on the bottom.

Just because you are able to scan something, doesn't mean that it is legal to do so. Most professional wedding, school, and portrait photographs are protected by copyright laws. This means that you cannot scan or copy them without the permission of the photographer. These copyright laws protect photographers who make their living by selling prints and copies of their photographs, so making your own copies by scanning or printing their pictures is akin to stealing from them.

The same is true of most books, magazines, newspapers, and brochures. If the image has a © symbol near it, then it is definitely copyrighted. Even if it doesn't, it may still be copyrighted. So, unless you took the picture yourself, you may not legally scan, print, display, distribute, or sell it without permission.

Starting With with a Digital Camera

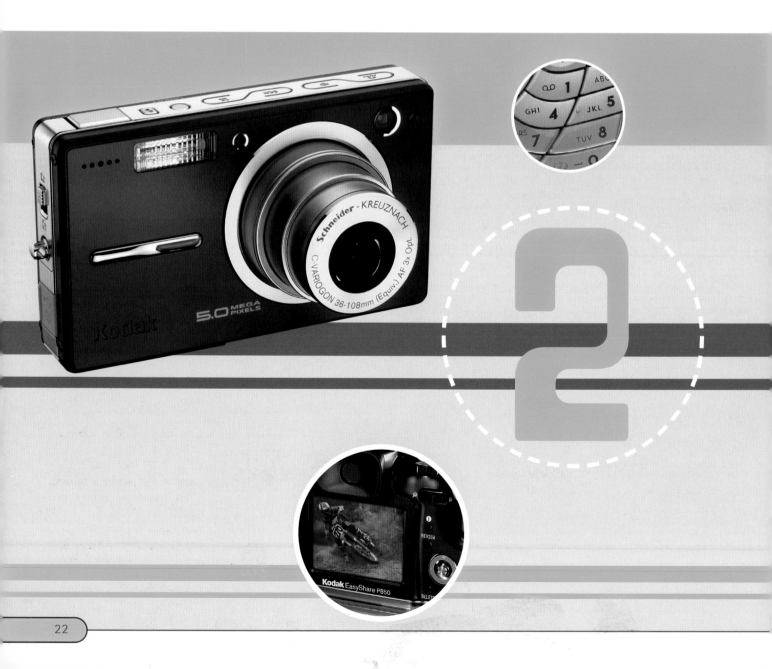

If you shoot with a digital camera, your pictures can easily be printed at home, in stores, or uploaded to www.kodakgallery.com.

If you are starting with a digital camera or camera phone, you are ahead of the game. Your pictures are already "digitized" by the imaging sensor and ready to be printed. Some home printers let you make prints straight from the camera or the camera's memory card—a small removable storage device that holds your digital pictures after you shoot them, (such as a Secure Digital —SD— or CompactFlash —CF— card). Other printers require that you print from your computer. Either way, you will want to transfer your images to the computer at some point and save them there. You should also save your images to a backup storage device, such as a CD, DVD, or Zip disk so that they are protected in case your computer ever crashes. (See page 24 for more about backup storage devices.)

"The beauty of a digital camera is that your pictures are ready to be printed an instant after you take them."

An imaging sensor replaces film in a digital camera. As light from the lens hits the sensor, the picture is formed. This information is then interpreted by the camera's internal computer and transferred to the camera's memory card.

Camera phone pictures are digital pictures that can be printed at home or uploaded to an online photo-finishing lab service like **Kodak EasyShare** Gallery (www.kodakgallery.com)

Protect Your Pictures

A digital picture is simply a computer file that tells your computer or printer how the picture should look when displayed onscreen or printed. And, just like any other computer files, digital pictures can become corrupted, or may accidentally be deleted or altered. Therefore, it is important to have a backup copy somewhere other than on your computer.

If you have a CD or DVD burner, or a Zip drive, you can save an extra copy of your important pictures to CD, DVD, or Zip disk. Another option is to upload your images to the *Kodak EasyShare* Gallery (www.kodakgallery.com) and order a CD copy.

Your Camera's Resolution

If you are in the market for a digital camera, the highest resolution the camera is able to shoot should be an important factor in your purchasing decision. Camera resolution is described in terms of image resolution, which is how many pixels (picture elements) make up the entire digital photograph. A megapixel equals one million (1,000,000) pixels. It sounds like a lot, but a 1-megapixel camera is actually considered a low-resolution camera. Refer to the list on the opposite page when shopping for a camera to see how many megapixels you need for your purposes.

1 megapixel: Good for emailing pictures and website fun, but not much more. Its resolution isn't high enough for making prints larger than about 2 x 3 inches (B8).

2 megapixels: Good for emailing, web use, and regular 4 x 6-inch (A6) prints.

3 megapixels: Good for all the uses listed above, as well as for producing photo-quality prints up to 11 x 14 inches (A3), and sometimes even larger.

4 megapixels (or more!): Even after cropping, images created at these high resolutions can make beautiful large prints—as large as poster-sized if you're shooting with 5 or 6 megapixels!

Photo File Formats

There are several file formats that digital pictures can be saved in, but the most common are JPEG and TIFF. These are files that end in the designations .jpg, and .tif, respectively. File formats go in and out of vogue as technology and preferences change, but JPEG and TIFF are by far the two most popular and versatile for home consumers.

A photograph taken with a 5 or 6-megapixel camera can be enlarged to poster sizes. If your home printer cannot make prints this big, you can upload the image to an online service like www.kodakgallery.com and order a 20 x 30-inch print (A1)!

JPEG

JPEG (.jpg) is a compression file format that can be reduced to one-tenth of its normal file size for storage with minimal loss of detail. Compressed files take up less memory on your computer's hard drive or your camera's memory card, and they can be downloaded more quickly than their larger non-compressed counterparts (such as TIFF files), which is one reason why JPEGs are so popular.

JPEG is a good file format for photos because it supports millions of colors and can therefore produce photo-realistic images. However, it is important to remember that, because it is a compression file format, it is considered to be "lossy." In other words, each time that you save or re-save a JPEG file, you lose some information, and the total file size gets smaller and smaller. Therefore, after repeated saves, you may start to see image degradation. Some cameras allow you to choose the level of JPEG compression, such as low, medium, or high. The lower the compression used, the higher image quality you will have, and the larger the file size will be. Medium to high quality (i.e., a low or medium compression ratio) is fine for most photos.

Most image-processing software will also allow you to select your rate of compression when saving a JPEG file. The compression option usually appears when you select "Save" or "Save as" from the File menu. Make sure the Preview box is checked so that you can see the quality change for yourself. Use the Preview feature and continue compressing until you see a change in quality, then go back up at least one step in quality before saving. Or, if you prefer not to lose any of your picture information, always save your JPEG files in the TIFF format before you do any image processing on them.

TIFF

The TIFF file format is excellent for photographic, retouching, and printing applications. The only real issue with this format for the home user is that it is uncompressed, and thus can have an extremely large file size when compared to a JPEG version of the same image. Also, some entry-level image-processing software does not recognize the TIFF format. If you'd like to be able to read and convert to this format, be sure that any software you invest in can handle it.

Selecting Your Image Quality

Most digital cameras give you a choice of what size file to select before shooting. The camera menu that controls this is often called Image Size or Image Quality. The size of the file is determined by two things:

1 The resolution—the total number of pixels you're shooting with.

2 The quality—the degree of compression applied to the file.

So, what's better for shooting pictures, a larger file size or a smaller file size? Well, bigger is usually better. The higher the resolution your camera can shoot at, and the higher the image quality you select (meaning less compression was used), the more options you will have later when you're deciding what size prints to

The Resolution Solution!

High Quality Setting = Better Looking Prints + Enlargements

Low Quality Setting = Fast Emails + Lots More Pictures

make. However, keep in mind that these large file sizes eat up more space on your camera's memory card, as well as on your computer's hard drive. Big files take longer to save, and longer to open on the computer. If you have an older computer, large files may even cause it to crash or freeze up.

On the flip side, shooting at a lower resolution and/or quality (using more compression) will result in a smaller file size. These small, low-resolution files are best suited for emailing, and you can shoot many more at a time without worrying about filling up your memory card or clogging up your computer. Unfortunately though, you can't use these low-resolution images for quality enlargements.

Future Use of Your Pictures

It's sometimes hard to predict how big you are going to want to print a picture. You may be tempted to select the lowest image quality setting on your digital camera because you can take so many more shots before filling up your memory card than you would be able to if you were using high image quality. However, there's no getting around the fact that low-resolution digital pictures are very limited in what size they can be successfully enlarged to. Your joy may quickly wear off when you get to the printing stage and find that these images only look good as tiny 2 x 3-inch prints (A8)!

On the flip side, high-resolution images can always be resized smaller for low-resolution applications like email and websites. Kodak's free *EasyShare* software will do this automatically. Or, see page 31 for details on resizing your digital pictures yourself.

© Rhonda Cox

Your low-resolution picture may look great on your computer monitor or when printed very small, but it will start to break up and look blocky as you make your prints larger.

"Low-resolution digital pictures start to break up and drop in quality when they reach a certain print size."

Downloading Your Images

Once you own a digital camera and have taken some pictures with it, you can transfer your images from your digital camera to the computer. This is called downloading, and can be done in several ways depending on the features of your camera and computer:

• One-touch transfer with a *Kodak EasyShare* camera dock or printer dock and your *Kodak* digital camera.

• Transfer by attaching a cord from your camera to a port on your computer, such as a USB or FireWire port.

• Wireless transmission from camera to computer (using WiFi, IrDa infrared, or Bluetooth wireless technology, for example).

• Transfer using a memory card reader that stays plugged into a port on your computer. Take the memory card out of your camera and place it into a card reader that is specifically designed to read the type of card your camera uses. (Some card readers can read multiple types of cards.)

• Create a picture CD at a *Kodak* Picture Maker kiosk or order one online, then load the CD into your computer.

After you've transferred the photos to your computer and know that they have been safely saved there, you can erase the photos on the memory card and start taking more pictures!

Downloading and uploading are like pouring information from one place to another, such as from your camera to your computer, or from your computer to an online photofinisher.

WiFi enables wireless communication between your camera and computer, or camera and printer.

The Modern "Bake Sale"

A few printers have "stand-alone" capability, meaning they don't need a computer to function. Just load in a memory card, or attach your camera (via cord, wireless connection, or *Kodak EasyShare* dock), and print! Forget selling cupcakes to raise money at a bake sale! With this kind of printer, all you need is a power source and you can take pictures with your digital camera and print them then and there! Instead of leaving with a fleeting, fattening cupcake, the buyer gets a wonderful keepsake portrait! (See pages 43-44 for more details on stand-alone printers.)

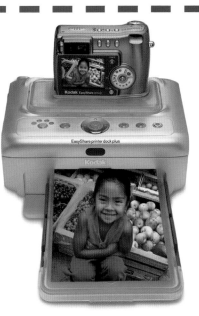

Stand-alone printers do not require a computer to make great prints. Simply insert your memory card into the printer, or connect your camera using a cord, wireless connection or *Kodak EasyShare* dock, and you're ready to go!

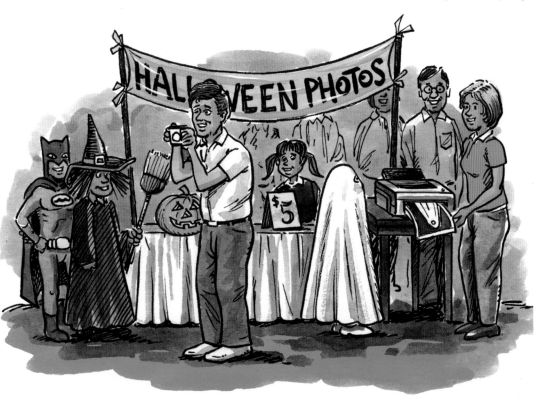

Pictures on Your Computer

Once a picture has been transferred to your computer, you can view it by using picture-viewing or image-processing software. (Most computers have a simple picture-viewing program included in the system.) Picture-viewing software is just that—it allows you to view your pictures on the computer, but not much more. It's very fast, usually taking only a few seconds or less to bring up a picture onscreen. But, it will not offer many options (if any at all) for improving how the digital picture looks. For this, you will need image-processing software.

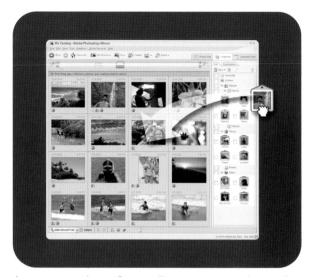

Image-processing software allows you to see tiny versions of your images, or click on them and see larger versions.

ImageLink System Simplicity

The new *ImageLink* print system is now available on many printers and digital cameras. This advanced new photo industry standard is designed to simplify at-home picture printing and provides effortless, one-touch picture printing from snapshot printers that incorporate *ImageLink* system compatibility. Simply place your *ImageLink* system compatible camera directly on the printer dock, then press a single button to make snapshot-sized (4 x 6-inch—A6—or 3.5 x 5-inch—B7) pictures in as little as 90 seconds. The *ImageLink* print system allows you to print without a computer, without cables, without having to scroll through complicated menus, and without a lot of time and effort! For more information, visit www.imagelinkprintsystem.com.

Resizing Your Photos

°If you have a high-resolution image that you'd like to email to a friend, you will need to resize your photo. To do this, open it in your image-processing software, such as Photoshop Elements. Next, save the image under a different name than what the original is called. This is a very important step! If you resize the photo and save it without changing the file name, the original high-resolution version will be overwritten and replaced by the current version. In other words, you will have erased the original photo! So, be sure to save the photo under a new name right after it comes up on your computer screen so you can retain the higher-resolution version for future projects.

Most image-processing programs have a command called Image Size, or Resize. Selecting a size of 4 x 6 inches (A6) at 100 ppi (pixels per inch) is a good choice for resizing a picture so it will email quickly and efficiently. (See page 41 for more about ppi and image resolution.)

Image-processing software allows you to make great improvements in the way your pictures look. In its simplest form, you can crop the image, improve the color and brightness, and remove red-eye. More advanced options include perfecting the image through changing the background, adding text, collaging, and much, much more. There are free image-processing programs available, including *Kodak EasyShare* software. (See pages 50-53 for more information about image-processing programs.)

Hint: Adding a "W" to the picture's file name that you plan to resize is a good way to indicate it is a lower-resolution web version. For example, if your image is called MyBirthday.tif, you could re-save it as MyBirthday_W.tif.

Getting Organized

3

"Keeping track of your digital photographs can be difficult unless you use specialized software to help."

When you first start scanning your film images, or shooting pictures with a digital camera, you'll probably save your pictures to your computer's hard drive. With certain computer operating systems, you may be prompted to save them to a folder called My Pictures, or another folder within your photo software program. This may be fine at first, but soon, as the number of pictures rises, it may become unmanageable.

A good solution is to develop a library-style system that will help you maintain and manage the thousands of images you may someday have. We recommend using a software designed for albuming, such as *Kodak EasyShare* software, ACD Systems ACDSee, Adobe Photoshop Album, or Jasc Paint Shop Photo Album, to name a few. Alternately, you can create your own unique library system of folders in your computer.

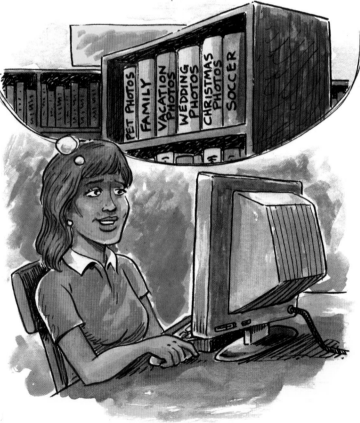

Think about your folders like photo albums, neatly arranged on the bookshelf, so you can always find the picture you are looking for.

Kodak EasyShare Software

One very helpful feature of the *EasyShare* software program is the system of albums and folders it helps you create to organize and store digital pictures on your computer. A copy of *EasyShare* software may have come with your *Kodak* digital camera or printer, or be included on a *Kodak* Picture CD. If you don't have a copy, you can download this free software at www.kodak.com/go/easysharesw.

 EasyShare software begins by locating all the digital photographs that are "hidden" in different places on your computer, then let's you view them as thumbnails (miniature version of your pictures) for quick visual reference. It can handle as many as 10,000 digital images and videos.

 Once found, the software will automatically sort the pictures by date. Or, you can move (use your mouse to drag and drop) them into separate albums for easy sorting. The albums can be named by date, or subject matter, or any method that works for you. (For more about *EasyShare* software, see pages 50-52.)

Other Albuming Software

Several other albuming software programs are also available, such as ACD Systems ACDSee, Adobe Photoshop Album, or Jasc Paint Shop Photo Album. Most allow you to view all of the photos on your computer, no matter which file folder you have them saved in, or how many you have. Some even see and organize photos you have archived on a CD. This system makes finding your pictures a breeze.

 Photoshop Album offers the ability to find photos by the date you shot them using an intuitive timeline screen, or calendar views. It also allows you to assign keyword tags (such as "Katie" and "Birthday") or full captions. It can then search for an image using these keywords, captions, timeline, or a combination of these. Paint Shop Photo Album offers several different ways to view your photos as well, all accessible with the click of a button. It's very intuitive, and takes only a moment

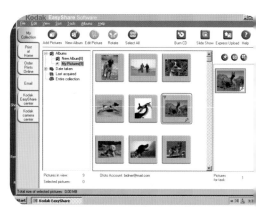

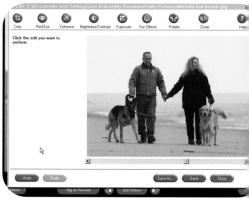

© Jenni Bidne

Kodak EasyShare software quickly sorts your pictures into albums, and shows you small "thumbnail" versions, as in the top photo. Double click your mouse on the thumbnail version you'd like to view, and a larger version of your picture will appear, as in the bottom photo.

Create Your Own System

to get started. ACDSee is a powerful, professionally oriented photo manager that helps you find, organize and edit your photos. You can instantly share your pictures online, on your cell phone, or create quality prints and slideshows.

Some albuming programs offer an archiving function that allows you to search for photos based on how you have used them. An example would be to find all the pictures you have emailed to your parents, friends, or colleagues in the past year! You can even ask certain programs to pull up photographs that have similar color characteristics for an art project, or when trying to select a photo that's colors are harmonious with the color scheme of your living room. Software with this capability enables you to find any photo on your computer or in your CD archives, regardless of where you purposely (or accidentally) saved it.

If you're a do-it-yourself kind of person, it's not hard to create your own system of folders to keep things straight. But without a software program like *Kodak EasyShare*, or another organizational software, you'll lose out on the unique search methods they offer. Even with a dedicated software program, however, a well thought out folder system will help you stay organized.

Creating folders on your computer, whether you're using a Mac or a PC, is a simple matter of going into the File menu, selecting New, then scrolling down to Folder (or New Folder, on some systems). The folder is created in whatever window you are currently working in. It will usually pop up as "Untitled Folder," with the text highlighted and waiting for you to name it. (If the folder is not highlighted, just click on it once with your mouse and begin typing when it is highlighted.)

Both Mac and PC offer simple solutions for viewing your picture files within each folder if you prefer to see more than just a file name. With a PC, click on the View menu, then select Thumbnails. With a Mac, click on the View menu and select Icons. Picture formats that are recognizable to your computer should pop up as a tiny thumbnail version in that folder.

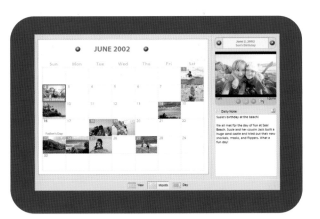

The "calendar view" system of organizing your photos not only makes pictures easy to locate on your computer, but it is also a wonderful and interactive way to view your pictures.

Naming Folders

When setting up your image library, you should begin by making a master folder for each year. Then, within those folders, make additional folders for individual months, seasons, or major events. Adding a date to the folder name will help you stay even more organized. Next, within the month, season, or event folders, you can make additional sub-folders if you wish to further categorize your pictures. For example, in your "2005" folder, you might have a folder called "Livonia Michigan." Then inside that one, you could have additional folders for various events that occurred in that locale, such as:

KatieBday

Thanksgv

Xmas

FunInSnow

Abbreviating your folder names keeps them short, but be sure the abbreviation you create isn't so cryptic that you can't remember what it means! If you shoot pictures for work, or for selling online, I recommend that you create a completely separate set of folders for these pictures so that they don't get mixed up with your personal collection. This way you'll easily be able to find the business or sales photos you need without digging through your digital photo albums!

Naming Individual Photos

Naming your individual photos is a lot harder than naming folders. For starters, your digital camera probably assigns them a default name, such as DCS_122—not very descriptive! Depending on how your camera is set up, it may name them sequentially, starting from the first picture your camera ever took. Or, it may restart at 001 each time the memory card is cleared. Check your camera's instruction manual to know what to expect.

If you have a choice, set the camera so it keeps numbering higher and higher, not starting again at 001 with each freshly cleared memory card. Not only does it make you feel good ("Wow, I've already shot 600 pictures with this camera—I'm really getting my money's worth!"), but it will also help you to avoid accidentally overwriting (erasing) another picture with the same name when you transfer the image files to your computer. You don't want that great picture of Katie called DCS_001 to be overwritten (and thus lost forever) by a newer DCS_001 picture you just shot!

If your camera doesn't let you choose how it numbers photos, just be sure to give each picture file a new name as soon as you download it. That way the DCS_001 picture of Katie will just be called Katie.tif, and downloading a new image called DCS_001will not affect it. Renaming your photos after you download them is always a good idea anyway. As you might imagine, finding a picture called Katie.tif is a lot easier than remembering where you put DCS_001! To change an image's name, open the folder you've saved it to so that you can see the small thumbnail icon. Then use your mouse to click the file name once (or in some cases, right-click the mouse) and type in a new name. (Keep in mind that some older computers don't allow names that are over eight characters long.)

It's easy to develop a method of abbreviating your file names. For example, pictures starting with KT might mean that the main subject is Katie. So KTplay01.tif and KTplay02.tif are pictures of Katie playing. If you want to remember when you took each photo, be sure to place it in a dated folder or an event folder, such as "Thanksgiv05." Later, if you wanted to find all the pictures of Katie from all your different folders, you can use your computer's Search (for PC users) or Find (for Mac users) function and search for "KT." Cataloging software will do this for you, but only if you take the time to assign a key word or set of letters to the set of individual picture files.

It is important to note that the date listed next to your picture file (as seen in the folder window) is not necessarily the date it was taken. That date will always reflect the date the picture was last modified and saved in the computer. Some cameras will record the date along with other picture information and attach it automatically to the image file, but others do not. Check your camera's instruction manual. Those of you who are more chronologically minded might prefer naming all your pictures with the date (Jan22-001.tif, Jan22-002.tif), and then storing them in descriptive year or event folders.

There are millions of ways to name your pictures and folders. The point is that you should develop a system that works for you. Begin the process by spending a few moments analyzing how you tend to look at your pictures. Are you more likely to try to find specific photos by date ("Remember that trip we took in August of 2005?"), place ("Where are those pictures from when we lived in Florida?"), or subject ("I'd like to print a bunch of pictures of Katie when she was younger.")? Once you're aware of how you think about your photos, you'll be able to come up with a file and folder naming system that works for you.

© Mimi Netzel

Choosing a Printer

"Inkjet printers are versatile performers that are able to print beautiful photographs, as well as general documents."

Two of the most common and reliable home printing methods are desktop inkjet printing and using a thermal "snapshot photo printer," such as the *Kodak EasyShare* printer dock. In terms of quality, inkjet printers range from adequate color output to stunning photographic images. These printers are versatile performers that meet many household printing needs, from letters and school reports, to photos for the family album. Snapshot photo printers, on the other hand, are designed for just one thing: producing great photo-quality prints, and fast! These printers usually print in just one size for convenience, such as 4 x 6 inches (A6), although some let you fill the 4 x 6-inch paper with wallet size pictures. It doesn't get much easier than a snapshot photo printer. Most have special cartridges that include paper and ink in one simple-to-load package.

Inkjet printers range from economical all-purpose printing units to high-end professional level units that are optimized specifically for printing photographs.

Thermal Printing

In addition to being simple to use, *Kodak EasyShare* printer docks have another advantage; they utilize advanced thermal printing that produces waterproof, stain-resistant pictures with vibrant color and excellent detail. These durable prints resist fingerprints and can be wiped clean. The *Kodak Xtralife*® lamination on the prints protects the image so it will last a lifetime under typical home display conditions.

Kodak EasyShare printer docks make printing easy by including a direct-to-camera connector. Simply place a compatible camera on the dock, select the images you want to print on the printer's monitor, and press the Print button! In short order, you'll have a print that looks and feels just like the ones you get from a photofinishing lab. If you have a computer, as an added bonus, *Kodak EasyShare* printer docks also let you transfer pictures from your camera to your computer at the touch of a button.

Which Type of Printer Should You Use?

Your first choice in selecting a printer is whether you want a desktop inkjet printer or the snapshot photo type. When it comes to inkjet printers, you have a wide variety of choices. Some high-end inkjet printers are made specifically for printing photographs, while others are all-purpose printers that can be used for printing things like documents or webpage printouts, as well as photos.

Snapshot photo printers are very handy, and can print out beautiful photographic prints without much effort. However, they are limited in terms of versatility. You can't turn around and print out a color newsletter, a business memo, or your child's term paper with them. These printers are best suited for making prints for friends, family, or photo albums. If your printing needs go beyond that, you may want to consider going the desktop inkjet route. Here are several things to consider when picking an inkjet printer:

Compatibility: First of all, the printer must be able to work with your computer's operating system (such as Windows XP or Mac OSX). To facilitate this, you may have to go online and download the latest printer driver from the printer manufacturer's website. A printer driver is simply software that allows your computer and printer to "talk" with each other. Be aware that if you have an old computer, it may not be possible for some printers to work with it, even if you download the latest printer driver. When looking to purchase a printer, you should talk with a salesperson to make sure that it's possible for the printer you are interested in to function with your computer's operating system. (The same problem can occur between an old printer and a new computer. It may not be possible for them to work together, so be sure to bring information about your existing equipment with you when you're looking to purchase new items.)

Connection Type: You'll need to select a printer that has the right kind of connection for your computer. Newer computers may have wireless (i.e., WiFi, infrared, or Bluetooth wireless technology) capability. Old computers might have a serial port. USB and FireWire are the most common connection types.

Ink Cartridges: Look for a printer with a separate cartridge for the black ink, especially if you plan to use the printer for letters, reports, and other non-picture documents with black type. That way, you can replace the black cartridge alone instead of having to trash an entire color ink cartridge when just the black ink runs out.

Printer Resolution: Printer resolution is measured in dots per inch, or dpi. This refers to the number of dots of ink that the printer is capable of laying down per inch of paper that it's printing on. The more of these small dots that it can fit in an inch, the sharper the picture it can produce. For practical purposes, a printing resolution of 1200 dpi or higher is more than adequate for producing photo quality prints at home.

Dithering Patterns: Each manufacturer boasts a proprietary dithering pattern for their printers. The term "dithering pattern" refers to the pattern in which an inkjet printer lays down the actual ink droplets onto the paper. Connoisseurs of inkjet printing will claim that one manufacturer's dithering is better than another's. The best advice is to check sample prints at the store before purchasing your printer. Deciding which dithering pattern is best is a very subjective and personal choice.

Image Resolution and Printer Resolution Are Not the Same!

Image resolution is defined by how many pixels are in a digital picture, and is often referred to in terms of ppi, or pixels per inch. Printer resolution is defined by how many tiny dots of ink the printer can lay down on a piece of paper, and is often referred to in terms of dpi, or dots per inch. (Even though ppi and dpi are often used interchangeably in the world of digital photography, their technical meanings are still different.)

Image resolution and printer resolution work together to make a quality print. In other words, no matter how many dots per inch your printer can lay down, your print won't look good if you started with a low image resolution. (Refer back to pages 26-27 for more information about high- and low-resolution images and their uses.) On most home printers, you're in good shape if the image resolution is at 200 ppi or higher. On the other hand, even if you're working with a high image resolution of 200 ppi, if your printer can't produce a high number of dots per inch of paper, you still won't get a good print. So, the key is to make the most of both types of resolution. Start with a high quality image (200 ppi or higher) and invest in a printer with a dpi capability that matches your needs (1200 dpi or higher, for most home printing needs). Other factors that affect print quality include the way the ink dots are laid down, the quality of the ink, and the quality of the paper (see archival quality information on page 42).

Paper Size: The average printer can print letter- and legal-sized prints, but may have trouble with extra small or extra large sizes. On the other end of the spectrum, some high-end printers can take rolls of photo paper to print banners and yard-long panoramic pictures. Others can print on extra-wide paper, such as 13 x 19-inch folio size (A2/A3). Determine what print sizes you'd like to be able to make, then look for a printer with capabilities that match your needs.

Paper Thickness: Consider the thickness and weight of the paper that the printer can handle. This is especially relevant if you want to use specialty printing papers. Even if a printer can physically push the paper through its rollers without jamming, if it's not that particular paper type, the inks may smear.

Stand-Alone Printers: Computer-free printing is a nice option, as well. Stand-alone printers can take the digital picture information straight from the camera itself, or from the camera's removable memory card. They're great for printing at parties, or other events. (See pages 43-44 for more about stand-alone printers.) However, in cutting out the computer step, you miss out on the chance to enhance your digital pictures using image-processing software prior

© Mimi Netzel

to printing. And remember, the pictures haven't been saved to the computer—they've only been printed. You still need to transfer them to a permanent storage location, such as your computer or a CD or DVD. (See page 24 for hints on saving and protecting your pictures.)

Archival Quality: The newest generation of printers offer archival and water-resistant inks. This is important if you are printing pictures that are meant to last for generations, or are hung on the wall. Archival quality pictures last longer without fading. Photos made with water-resistant inks hold up to smudging and spills better than traditional inkjet prints. Don't forget to consider the archival qualities of the paper, as well. *Kodak Ultima Photo Paper* uses *ColorLast* technology, making it resistant to fading caused by light and pollutant gases, resistant to smearing in high humidity, and resistant to fading or yellowing when stored in dark conditions. (See pages 60-75 for more information on printing papers.)

© Janet Anagno

© Janet Anagno

Sun, pollution, and humidity can all cause photographs to fade. Many of us have prints from the 1970s and 1980s that are faded and off-color now. Non-archival inkjet products will fade even faster than our old prints did—in a matter of months rather than years or decades! For inkjet prints that will last for generations, always select archival-quality products.

Price: Let's not forget one of the biggest considerations—price! Remember, it's not simply the cost of buying the printer that you need to consider. Find out how much the ink cartridges cost and how many average photos can be printed per cartridge. Find out how much the paper will cost. Then add all this together to get a rough estimate of how much you'll be spending per print. Some printers and their equipment add up to a much more expensive per-print cost than others.

Evaluating Sample Prints: Some stores have display models of the printers that they sell. Ask to see a sample print before buying. When reviewing the print, ask yourself these questions:

1 Does the print look smooth and rich? Look at a large solid-color area, such as the sky. These areas are more likely to reveal any flaws, such as streaks, bands, or blotches.

2 Is the tonality smooth and continuous? Bad color registration or blurs from wet ink being tracked are easily visible in lighter areas of the photo.

3 Are the flesh tones pleasing and even? Many of your favorite pictures will be portraits of friends and family members. Flesh tones that look greenish, or too ruddy are not very attractive.

4 How well are the details rendered? Strands of hair or the texture of a fabric are good areas to check.

Stand-Alone Printers

Most home printers require a computer connection. However, both desktop inkjet and snapshot photo printers are available in stand-alone models that allow computer-free printing. In other words, they do not need to be linked to your computer in order to print. Instead, you can send images straight from the camera (using a USB cord, or WiFi, for example) or insert the camera's removable memory card into a slot on the printer.

This type of quick and easy printing is great fun. A natural application for this would be your child's birthday party. By bringing the printer downstairs to the living room or dining room, you can print out souvenir photos right then and there for each guest to take home. You could even bring your printer to a wedding reception, and print out shots of the bride and groom before dinner is even served!

Another useful scenario is for families who have scheduling problems over use of the computer. There's no sense in tying up the computer or slowing it down with picture printing while other family members are waiting for their turn. Simply set up your stand-alone printer in a location that's convenient for everyone and you can print pictures without interrupting anyone else's computer time.

If you have a black-and-white laser printer that you use for your everyday printing jobs, you might not want the inconvenience of adding another printer to your system. Some people may have enough ports to plug in two printers at the same time (using their computer's Print menu to select which printer to use for each job), but if you're someone who has to crawl under the desk each time to swap out printer cords, you'll soon wish you could skip the hassle and print directly from your digital camera or removable memory card.

Many new stand-alone printers offer a choice between direct camera connection (DCC) and WiFi or Bluetooth (which connect the camera and printer without any cords). Slots for different types of memory cards are also common. Inserting your removable memory card rather than attaching the camera is handy if you want to free up the camera or con- serve battery power for more picture taking. If the printer can accept several different types of memory cards (i.e., it has multiple slots for different card formats), this gives you more lee- way should you decide to upgrade to a different camera. Some stand-alone printers even have wireless connection capabilities for transfers from com- patible cameras, laptops, cell phones, and PDAs (personal digital assistants).

An especially useful feature to look for when choosing a stand-alone printer is a monitor that you can use to prepare your image for printing. The simplest printer monitors are just fancy information panels that let you scroll through the printing options. More helpful are monitors that let you preview the image and even crop or enhance it before printing. The limited memory in the printer, however, could cause long delays in previewing the images (in comparison to working on your computer). For the fastest operation, look for printers with a memory capacity of 16 MB or more.

Don't Want to Print at Home?

Don't worry! If you haven't found the perfect printer yet, or don't want to invest in a printer right away, you can still get started with digital printing by heading to a nearby retail store. Many stores have *Kodak* Picture Maker kiosks. These self-serve kiosks allow some or all of the following functions (depending on the particular kiosk model):

- Accept images from your digital camera, camera phone, removable memory cards, or a picture CD.

- Scan older prints to create additional copies.

- Make image improvements, including zoom, cropping, red-eye reduction, color enhancement, and color adjustment.

- Convert to sepia or black-and-white.

- Add text, with the ability to select size, placement, color, and font.

- Add a border, including decorative, seasonal, special sentiments, and calendar designs.

- Print multiple copies in multiple sizes.

- Receive prints in seconds.

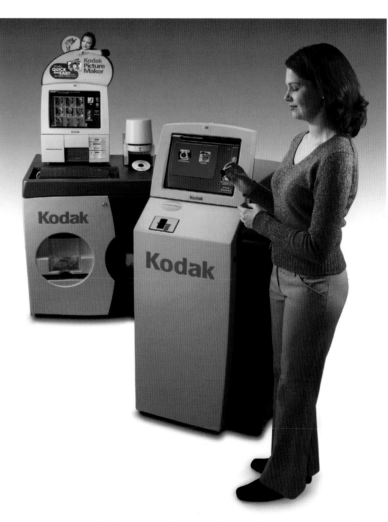

Kodak Picture Maker self-serve kiosks can be found in many stores across the country. Log onto www.kodak.com to locate the one nearest you.

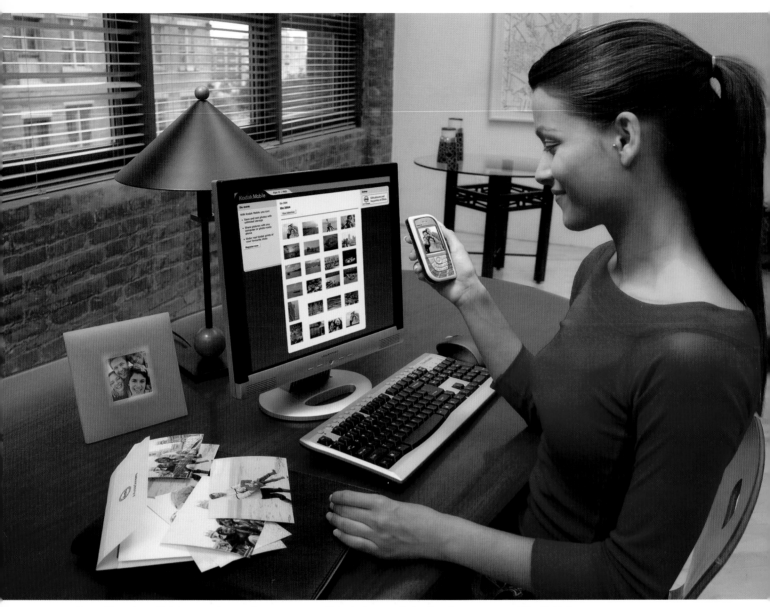

An online photofinisher can be used to turn your digital pictures (whether from scans, a CD, digital camera, or camera phone) into prints and photo gifts.

Online Printing

Another option is to use an online printing service like the *Kodak EasyShare* gallery (www.kodakgallery.com). You can upload your digital pictures to their site using the following instructions, then order prints, gifts, and more. The first step to online printing is uploading your photos. Uploading is a simple task. All you need is an Internet connection and some digital photos on your computer! Use your Internet service to go to www.kodakgallery.com and fill out a free registration. Then click on the Add Photos tab. There, you'll be able to name your photo gallery (album) and include a description. Then, follow their easy instructions for uploading your pictures. Once you've created one or more photo galleries using *Kodak EasyShare* gallery, you can:

- Improve your pictures with simple enhancements like cropping, red-eye correction, color adjustments, and novelty borders.

- Order prints in sizes from 2 x 3-inch wallets (A8) to giant 20 x 30-inch posters (A1).

- Share your gallery with friends and family so they can view it on their own computer and order the prints they want.

- Order framed photos as gifts. The site even lets you preview how the picture will look in the frame!

- "Publish" hard cover photo books with pictures and text that will be the envy of every scrapbooker you know.

- Create customized greeting cards from your photos. The cards can be inscribed with personal messages and mailed directly to the recipient for speedy delivery, or sent to you for posting at your leisure.

- Design the perfect holiday gift in the form of a 12-month calendar.

- Create photo clothes, like aprons, t-shirts, and sweatshirts.

- Make novelty items like photo mugs, mousepads, and playing cards.

- Order an archive CD (great as a back-up, or for sharing your pictures).

Let's Start Printing!

5

"You can often get good results with the default settings on your printer, but great results may require a bit more."

Anyone who has used a computer at the office, library, school, or home has printed a document. You probably selected Print from the File menu (or perhaps you used a short-cut key command, such as Control+P). It's easy to print a Microsoft Word document or an email this way, but it begins to get more complicated when you're printing photos because there are more choices and more things that can go wrong.

Most home printers connect to the computer with a cord or a wireless connection. When you initiate the Print command, a menu box usually pops up that walks you through the process. (If it doesn't, you may need to update your printer driver through the manufacturer's website. Look for a link that says "Downloads," or "Drivers"—see page 40 for more about printer drivers.) If you simply click the Print tab in the pop-up menu, without making any changes to the photo, you may get what looks like a good picture. But if you were to view it side by side with a photo that had been optimized with image-processing software, you would likely see a vast difference. Not every photo will require extensive correction and, in fact, most won't. However, almost every photo can benefit from a few touchups. Using image-processing software like *Kodak EasyShare*, and taking just a few moments to make color or contrast corrections with just one touch using the Enhance button will markedly improve your image. Even selecting a different paper can make a surprising improvement.

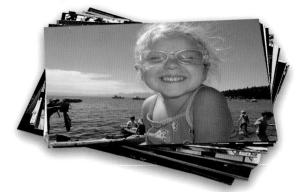

Optimize your prints for the best color and contrast using image-processing software, then choose the perfect paper to print with.

The Easiest Way to Print

One of the easiest ways to start making consistently good prints is to load Kodak's free *EasyShare* software onto your Mac or PC computer. If you own a *Kodak* digital camera or printer, it probably came with an *EasyShare* software CD. If you don't have the CD, or if you own a different type of camera or printer, don't worry! The software is available free at www.kodak.com/easysharesw. Simply log onto the site and follow the prompts to download the software. Be sure to load the version that matches your computer's operating system, such as Microsoft XP or Mac OSX. When your computer prompts you to install the software, click Yes.

Once your software is installed, click on the *EasyShare* software icon to bring the program up on your screen. You will then be prompted to choose whether you want *EasyShare* to be the default software for opening certain photo file formats (see pages 25-26 for more about file formats). Choosing *EasyShare* as your default photo software means that most photos that you click on will open up in this program.

Kodak EasyShare software is available free from Kodak. Just enter this web address into your Internet browser's address bar: www.kodak.com/easysharesw. It only takes a few minutes to load onto your computer.

One Touch to Better Pictures

Great inkjet prints depend on more than hardware alone—they are a combination of ink, paper, and the capabilities and nuances of the individual printer. Every model of printer is different, so results with the printer's default settings can vary significantly. Using the right printer driver settings (see page 40) is one of the easiest steps you can take toward better prints. Your printer driver will use a profile to adjust the output of ink to match the colors, contrast, and brightness in the picture file. The result will be better, more consistent, and even amazing prints—all automatically!

Sound complicated? It's not. The latest version of *Kodak EasyShare* software will automatically tell your printer what driver settings to use. All you need to do is select your printer model from a list, and *EasyShare* software delivers the simplicity of one-touch printing. If you're using other photo software, you can acquire the proper print quality settings for *Kodak* papers from www.kodak.com/go/inkjet/ and set them manually.

Eastman Kodak Company technicians have created specific printing profiles for over 270 of the most popular inkjet printers, including models from Canon, Compaq, Dell, Epson, HP, and Lexmark. As new printers come onto the market, additional profiles are constantly being added.

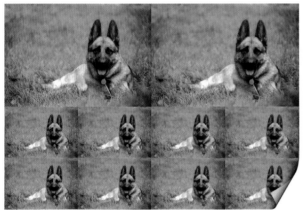

© Janet Anagnos

Kodak EasyShare software can help you create printing templates for single or multiple prints. As in the top example, you can print four 3-½ x 5-inch (A6/A7) snapshot prints on one 8-½ x 11-inch sheet of paper (A4). Or, as in the bottom example, you can print a combination of wallet-sized prints and snapshot prints.

Kodak EasyShare Software

Kodak EasyShare software is far more than just printing software. The following are a few of its many additional capabilities:

- Finding and organizing digital pictures (and video files) on your computer.

- One-touch emailing of photos to friends and family (including automatic resizing to an email-friendly size).

- Correcting and enhancing images.

- Printing beautiful pictures at home.

- Uploading images and videos to *Kodak EasyShare* Gallery (www.kodakgallery.com) for the convenience of ordering photo novelties, prints in sizes up to 20 x 30 inches (A1), or creating your own hardbound photo books online!

- Creating slide shows that can be emailed to others.

- Easy CD/DVD burning for users with CD/DVD burners

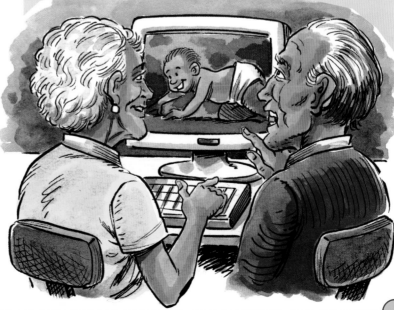

Several other programs in addition to *Kodak EasyShare* software offer printing help. In some cases, the software is designed for albuming (organizing) and printing, such as ACD Systems ACDSee, Adobe Photoshop Album, or Jasc Paint Shop Photo Album. Other programs include printing aids and templates within an image-processing program, such as Adobe Photoshop Elements, Jasc (Corel) Paint Shop Pro, Microsoft Digital Image Pro, Microsoft Picture It!, and Ulead PhotoImpact.

Each of these programs, with varying degrees of complexity and features, allow you to make improvements to your images prior to printing, including conversion to sepia or black-and-white. They also allow you to preview the layout of individual photos, picture packages (i.e., multiple prints on one sheet of paper), and contact sheets or index prints before you actually print them (although the actual configuration of these print layouts varies by software program).

Like *Kodak EasyShare* software, many of these programs allow you to automatically resize your images for low-resolution applications like email, computer slideshows, mobile picture phones, TiVo, and PDAs. Why is this important? In emails, for example, if the high-resolution versions were sent, they could take many minutes, or even hours, for the recipient to download, depending on the speed of their Internet connection. Some people may not be able to download large files at all.

The beauty of allowing software to create low-resolution files for these purposes is that you no longer have to perform the task of resizing images yourself. Not only is resizing time consuming, but it has the added risk that you might accidentally overwrite the high-resolution version with the email version, thereby losing the higher-quality image forever. (See page 31 for more details on resizing digital pictures.) Check the instructions in your software's Help menu carefully to check whether this is a temporary change or permanent (where you could accidentally lose the high-resolution original by accidentally saving the low-resolution version under a new name). *Kodak EasyShare* software creates a low-resolution copy to prevent this from happening.

The following are just some of the many software options available to help you optimize your image-processing, printing, and organization.

ACD Systems ACDSee: This software is a powerful photo manager for finding, organizing, and editing photos, as well as for creating quality prints and computer slideshows.

Adobe Photoshop Album: This albuming software simplifies printing and emailing of pictures, and helps you create slide shows with captions and transitions.

Jasc (Corel) Paint Shop Pro: Don't let the name fool you; in addition to digital art and graphics capability, this program offers a complete set of image-processing tools. And with Paint Shop Pro's print options, you can easily print out your work and share it with everyone.

Nova Development Photo Explosion: This software allows you to utilize automatic or advanced manual control for photo effects, creating photo albums, greeting cards, websites, and more. A large library of special effects and templates (including frames and borders) is included.

Microsoft Picture It!: This software offers image-processing tools and built-in wizards to make it easy for everyone to improve their photos. Get started quickly with 1,500 pre-created templates for photo cards, frames, calendars, and other photo projects.

Ulead PhotoImpact: This software provides a basic mode that streamlines common tasks, as well as a complete set of high-end tools for retouching, montages, painting, drawing, and web graphics. It also offers easy sharing modes, from printing templates to fast creation of webpages, as well as albuming options.

Saving Versions

Every time you alter an image—making it smaller for easy emailing, cropping it, or manipulating it in photo software—you risk accidentally hitting save and erasing the original version. It is almost always a good idea to hang on to your original image, unless you are sure that you want the changes you made to be permanent. If you save over the original, you can't go back to it later to access the highest resolution possible for that image, or the uncropped, unaltered version if you decide to try something different.

So, take this piece of advice: Whenever you want to alter an image in any way, start by selecting "Save as" from your File menu. This gives you the opportunity to change the file name to something new so you don't save over the original. You can change the name altogether, or you can simply add an additional character or two to the name so that you know it's a different version (i.e., KTbday.tif and KTbday_ver2.tif, or KTbday_lowres.tif).

If you're looking for a little less to worry about, remember that some softwares eliminate the need to make separate versions when emailing. These programs will temporarily resize the image without permanently affecting the higher resolution version that you have saved. This can be a terrific time-saver, and is an often overlooked benefit that you should keep in mind.

More Printing Options

Many image-processing programs have templates that simplify the printing of photos. Templates allow you to select from various pre-determined picture arrangements when you go to print. In some programs, the template selections simply allow you to position one, two, four, or more photos on a single sheet of paper. You just select the template you want to use and which digital pictures you want to print. Some programs even provide fantastic graphic templates for collages, and more.

Printing with Word Processing Software

Specialty papers with pre-cut shapes (such as address labels or CD stickers) can be tricky because you want your pictures and graphics to line up perfectly with the pre-cut shapes. Paper that comes packaged with a printing software CD makes this process simple and automatic. If there is no CD, check the manufacturer's website for software downloads.

If no software is available, or if it is incompatible with your computer system, you can make your own template manually in a word-processing program like Microsoft Word. Check the paper package for instructions on what size margins to set so that when the picture is printed it matches the right spot on the paper. Begin by opening a new document. If you're using a paper size other than 8.5 x 11 inches (often referred to as letter sized—A4), click on the File tab and scroll down to Page Setup (or Document Setup in some programs), then Paper. You can now enter the measurements of the paper you are using. Now click

on the Insert tab and scroll down to Picture, then From File to place the first photo. You'll need to tell the computer which photo to use by selecting it from the appropriate file folder. Next, click on the View tab and scroll down to Rulers so you can place the photo precisely to match the measurements that came with your paper. Drag the photo so that a top corner is in the correct place. Then tug at the corner of the picture box with the mouse to make it larger or smaller as needed.

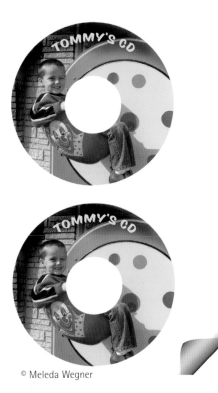

© Meleda Wegner

Some specialized paper comes with software that helps you place the photos on the page for proper printing. Other paper will give you margin sizes or other instructions for manually placing the photos using word-processing software.

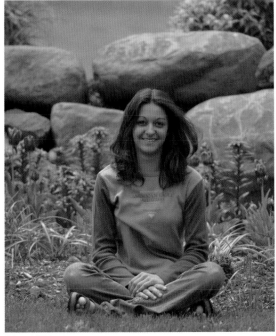

© Jenni Bidner

Hint: Pulling on the sides or top and bottom of your print can stretch or squash the picture. Tugging on the corners, however, will keep not distort the image.

In some word processing and simple graphic programs, if you use your mouse to drag on the side of the photo (rather than the corner), you will stretch and distort it. This can be fun to play with, but if you want to avoid stretching your image and maintain an undistorted picture ratio, direct your mouse to the corners of the image, or use the Constrain Proportions command (or a similar command, depending on your software).

Now You're Ready to Print

Regardless of whether you use *Kodak EasyShare* software, word processing software, or the software that came with your printer or camera, you will probably see a printing menu pop up on your monitor when you select the Print command from the File menu. This pop-up Print menu (sometimes called a Print Wizard) will likely offer choices similar to these:

Number of Copies: Paper and ink can be expensive. So, even if you plan on making multiple copies, it's still smart to begin with just one. Once you're sure it's perfect, you can print the rest all at once using the same settings.

Paper Quality: Select the quality you'd like to print at, such as Draft (or Economy), Normal, or Best (photo) quality. Depending on the software you're using, the options may appear by paper type or even brand name, such as *Kodak* Ultima Photo Paper, for example. (See pages 60-75 for more about paper selection.) Draft quality prints are done quickly (with less ink) to save time and money, but this will not produce a photo-quality print.

Hint: Manually placing small or odd-shaped pictures (such as fingernail decals or tattoos) often allows you to fit more on a page than you would be able to with a printing template.

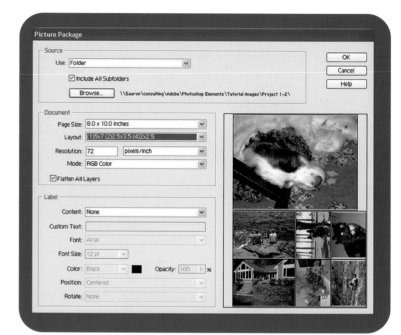

Most printer and photo software has printing or page template pop-up windows, often called Wizards, that can guide you through processes such as previewing a page before you print, or designing a multiple-photo page to avoid wasting paper.

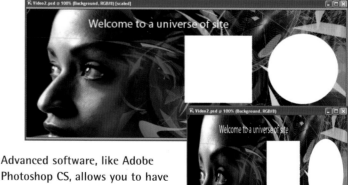

Advanced software, like Adobe Photoshop CS, allows you to have complete control over stretching, compressing, or distorting your pictures for creative purposes.

Photo Sizes: Depending on your printer, you can print anything from small individual 3.5 x 5-inch prints (A6/A7) to letter-sized 8.5 x 11-inch prints (A4), sometimes larger or smaller. Check your printer's specifications to be sure of the size options available to you, but extremely large or small print sizes are usually offered only on high-end printers. If you're using software such as *Kodak EasyShare*, you can pick templates, such as 6-Up Wallet, which prints six wallet pictures on one piece of 8.5 x 11-inch paper (A4). You then cut it up yourself. Paper that has perforations or die-cut shapes often comes with software for lining up the photos, or you can download the software from the manufacturer's website.

Paper Orientation: Do you want the printer to print the picture vertically like a normal letter (Portrait mode), or horizontally, where the picture is wider than it is tall (Landscape mode)? Some printer software lets you see a preview of what the image will look like on the page before you print.

Top and Bottom: This option allows you to print on both sides of a sheet of paper. However, most inkjet paper has a particular side that's the front and the back. The front, or top, is designed to take the ink, and the back, or bottom, is of a different texture that is not intended for ink. If you want to make two-sided prints, such as for a brochure or book format, be sure to buy two-sided paper.

Paper Type: Here, you can tell the printer what type of paper media you are printing with. (See pages 60-75 for a comprehensive list of different papers.) A higher-end printer will alter its printing speed based on the type of media you tell it you are using. Some media types take longer to dry, so they could smear if they run through the rollers too fast.

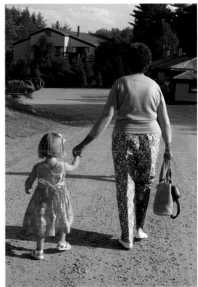

© Meleda Wegner

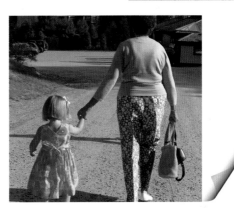

Selecting the correct paper orientation affects whether your picture prints vertically or horizontally on the paper. If your picture is a vertical shot, select Portrait mode. If it is a horizontal shot, select Landscape mode. Choosing the wrong orientation may cut off parts of your picture, as in the example above. This vertical shot was printed in Landscape mode, which cut off the top and bottom of the picture. Use the Preview feature if it's available to you and check the page layout before you print. This will save you valuable time, paper, and ink.

Ink Levels, Cleaning, and Alignment: Most printers will keep you informed about your remaining ink levels, as well as give you a pop-up window to ask whether you want to "Clean Heads" or "Check Alignment." If your printer has not been used for awhile, click Yes when you're asked to clean the heads and check alignment. It will probably save you money in the end. You should switch to cheap paper for this chore.

Which Printer?: You may be asked to select which printer you want to use if you have more than one printer connected to your computer (either with cords or wirelessly). In some cases, you may need to remove the cord of one printer from the computer and replace it with cord that connects your photo-quality printer. If you know you'll be printing, it is a good idea to connect the appropriate printer to the computer before turning the computer on. Otherwise, you may have to restart your computer to allow it to recognize the new connection.

Make Some Test Prints

When you first get your printer, you should make a test print before doing any serious printing. This test will help you figure out how to consistently create good results in the future. First, look for flaws such as smears, lines, or blotches. If you've purchased a quality printer and it is functioning properly, these flaws should not be visible. (Ideally, you should examine a test print from the printer you wish to purchase before you bring it home with you! This can help to avoid any unpleasant surprises during your first home test print.)

The next check you need to do is a bit more complicated. You can change the printer resolution by selecting the print quality in the printer driver software window that pops up when you ask your computer to print a picture. (See page 40 for information

about printer drivers.) Manufacturers have different names for these quality settings, but usually they are something like Draft or Economy (for a low resolution print), on up to Photo Quality or Best (for the highest resolution print).

Once you've made this selection, you can see how well your images print at various sizes. (See page 41 for information about printer resolution and image resolution. You can resize the image if you want to print the image smaller or larger than what the current value allows. However, watch out when changing the dpi/ppi setting on your digital pictures. Make sure that the software constrains the figures so that when you double the dpi (go from 150 to 300), it halves the print size (8 x 12 inches—A4—to 4 x 6 inches—A6). This keeps the total number of pixels the same. Accidentally doubling both will create an inferior, grainier picture. The icon for the constrain proportions command sometimes appears as a chain or a lock. Refer to your specific software's instruction manual, or use the Help command for more information.

Start at 300 dpi and make a 4 x 6-inch print (A6). Then go to 225 dpi and make another 4 x 6-inch print. Then repeat this at 150 dpi. Once you've made a set of prints, you'll want to take a few minutes to evaluate them. Check the lighter areas and large solid-color sections to make sure the color looks smooth. Then check critical details like strands of hair and eyes. If 300 dpi looks the same as 225 dpi, then you know you can print at 225 dpi and still get the results you want. This also allows you to make prints up to a third larger than a print made from a photo set to 300 dpi would allow.

You can fine tune the numbers until you have found the lowest image resolution you can use and still get quality results. Write this number down because it will control how large you can successfully print your digital pictures. The goal is to figure out the lowest resolution that will give you acceptable quality. Most of the time, you can just select 300 dpi and be totally safe. But if you want to start making big prints, you may start "running out of pixels" at 300 dpi, and will want to drop to the lowest acceptable number.

© Mini Netzel

Fun with Paper

"Buying paper shouldn't be an afterthought. The right choice can make a big difference in your pictures."

Many people spend a lot of time picking out their printer, but then grab the first box of paper they see, or whatever is on sale. What they don't realize is that their paper choice could be the single most important decision they make (next to the printer, of course) when it comes to making good prints. Regular copy paper simply isn't made for inkjet inks. The results are dull and blurry because the inks bleed together. Worse yet, copy paper could jam your printer, or smear wet ink on the rollers.

Quality paper delivers better colors, sharper details, and longer print-life. Which type you select depends on your personal preferences and goals for the picture. Some specialty "papers" have a polyester base with a plastic like feel, while other printing packages even include a magnetic substrate for creating photo magnets. The diversity of specialty papers available for sale is a real eye-opener. Special project papers will keep your family busy with fun and exciting art projects, as well as help you improve your business presentations.

When you walk through the paper aisle in an office supply or computer store, the selection can be daunting. There are different brands, sizes, paper weights, surfaces, and more to decide between. Where do you start?

© Kevin Kopp

"Cheap papers don't usually yield great prints. And worse, they can jam your printer."

Printing Possibilities

There are several different basic types of paper, depending on your printing needs. If you are using a snapshot printer that takes cartridges, the choice is easy—you need to buy photo paper cartridges specifically made for that printer. But if you have a standard inkjet printer, your choices will be many, and making the selection can sometimes be overwhelming. Your first decision is whether or not you want a print that looks and feels like a traditional photograph. Or perhaps your project requires a thinner sheet that reproduces the photo well, but can still be easily folded. A third option is paper for a quick draft copy where its only function is for checking spelling or placement.

Plain copier paper should always be avoided. Not only does it deliver washed-out looking prints, but the printer isn't set up for its porous surface. The paper comes out wet and ink-logged, which means your rollers are tracking ink, and they might even jam. Look for paper specifically made for inkjet printers (rather than for laser printers or photocopiers).

Your cheapest option is to select lightweight inkjet paper for drafts, memos, letters, and school reports. If you plan on printing photographs, switch to photo-quality paper in a letter weight (20 lb. to 27 lb.). For photos that feel like traditional photo lab prints, switch to even thicker photo-quality papers.

Paper Weight

When you go to buy paper, you will find that its thickness is described in terms of how many pounds a certain number of sheets weigh. Therefore, a number such as 24 lbs. will be a lot thinner than a higher number like 80 lbs. Thinner paper is usually cheaper to purchase. You don't need to use heavyweight photo paper for every situation. Instead, have several types available and match the job at hand to the proper paper type.

Standard Inkjet Paper: This type of paper is comparable to the weight and thickness of most copier papers. It is generally designed to be printed on only one side. If you look at both sides carefully, there will be an observable difference between the two sides. The best uses for standard inkjet paper include:

- Rough drafts and everyday applications
- Letters and documents that include both text and pictures
- School term papers
- PTA flyers
- Yard sale or puppies-for-adoption flyers
- Large projects that require numerous copies

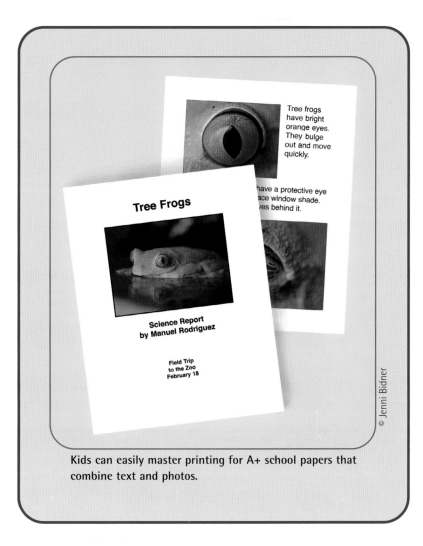

© Jenni Bidner

Kids can easily master printing for A+ school papers that combine text and photos.

Photo Papers: These papers are designed to look and feel like the prints you would get from the photofinishing lab. Best uses include:

- Quality photographic prints for friends or relatives
- Great prints for albums and display

Perforated Media: These papers have perforated (easy to tear) or pop-out (pre-cut) shapes in standard sizes, such as for printing greeting cards that are inset with micro-perforations (fold and tear) on an 8.5 x 11-inch sheet (A4). Just make the print area slightly larger than the cutout so that there is no white edge when you separate the print from the sheet. Die-cut edges (rather than fold and tear perforations) give the cleanest edge. Best uses for this type of paper include:

- Borderless prints
- Multiple prints on one page
- Business cards

Double-Sided Paper: Most inkjet paper is designed to be printed on only one side. When you have a need for two-sided printing, you'll need to buy this type of specialized paper. Be sure to let the first side dry completely before you run it through the printer again for the second side. Best uses include:

- Brochures
- Term papers
- Family newsletters
- Book-style projects

Dear Grandma,
Thanks for the birthday gift!

If you print out your photos and artwork on light, letter-weight paper, they can become creative, personalized stationary. The image used in this example was altered using image-processing software to 35% opacity before it was printed. This caused it to appear faded, or semi-transparent, so writing would show up better. Search for "opacity" using your image-processing software's Help menu or instruction book to see if you can produce this effect.

Business Papers: There are a number of papers that make it easy to create professional business materials, including the standard inkjet papers, perforated media, and double-sided papers we've just discussed. The best part of printing business papers yourself is that each client can get slightly different versions, and you can make up-to-the minute changes in the information without having to call someone to stop the presses! Gone are the days of being stuck with stacks of outdated brochures made by a printing company. Best uses for this type of paper include:

- Tri-fold brochures
- Business cards
- Clear plastic overhead transparency materials
- Newsletters
- Company mailings
- Client communications

Art Papers: There are many types of paper and media with special surfaces for fine art applications and crafts projects. Common choices range from a canvas-like texture to the rough pebbled feel of watercolor paper. Best uses include:

- Images with a painterly feel
- Portraits
- Crafts projects
- Stylish stationary

Image Transfer Media: This "paper" is sometimes called "iron-on," or "fabric transfer" media. It is a two-part process. First, you print on the media, being sure that your printer is set for this paper type. Then, you transfer the print to fabric (or another surface—read the instructions that came with the paper to see what it can be used for). Best uses include:

- Unique t-shirts and sweatshirts
- Quilt blocks
- "Real" faces for cloth dolls
- Curtains
- Crafts
- Coffee mugs

© Jenni Bidner

Image transfer papers are certainly not limited to t-shirts! Imagine using them to make quilt blocks for a personalized heirloom.

Hint: The transfer process reverses the image, so any writing will appear backwards. To avoid this, open your picture or artwork in image-processing software and flip it horizontally to make a mirror image. On your monitor, everything will look backwards, but once you transfer it to the intended surface it will look right.

Using Image Transfer "Papers"

Image transfer paper (also called iron-on paper) can be printed on using your printer, and then transferred to various surfaces. There are several types available, so check to see that the kind you buy can be used on the surface you want to transfer your image to. Possibilities include fabric (t-shirts, sweatshirts, quilt blocks, etc.), ceramics, wood, glass, and more.

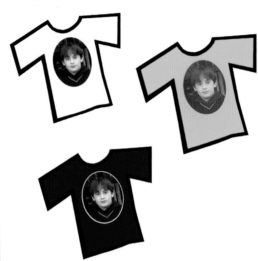

© Jenni Bidner

When transferring to fabric, regular fabric transfer sheets look just fine on white, but look faded or off-color on darker fabrics. For truer, crisper images on dark fabric, use transfer paper designed specifically for dark fabrics.

Remember if you have added text to your photo (or there are letters, such as a sign, in the picture), then you need to reverse it before making a transfer. This is because the transfer method reverses the picture, so actually printing it backwards will make the final product look right.

Hint: You'll need to trim the image carefully before transferring to avoid unsightly white edges.

"Regular prints are great, but there is so much more you can do."

Paper Rolls: A few specialized printers can spool rolls of paper instead of individual sheets. Not only is this a money saver, but you can also make extra-long, panoramic prints. Some of the best uses include:

• Panoramic (extra-long) images
• Banners
• Wallpaper borders

Greeting Cards: You can make greeting cards that look as good as or better than those from the store. Special greeting card paper comes with matching envelopes. After printing, these special papers allow for easy folding into card shapes. The part that becomes the front of the card is usually a photo-weight glossy paper. Often, the inside is left blank for you to write in, but some types of card media are made so that you can print on both sides. This allows you to print a typed greeting on the inside of the card. Best uses for greeting card papers include:

• Holiday cards
• Party invitations
• Moving announcements

Some specialized printers allow for extra-wide or extra-long prints.

Adhesive Papers: Adhesive papers are good for more than just address labels and CD covers! They're great for making your own stickers, as well as for craft projects. White adhesive paper will give the boldest colors, but transparent adhesive media will allow the color of the object it is stuck upon to show through. Just be sure that whatever adhesive paper you buy is designed for inkjet printers, not laser printers. Best uses include:

• Address labels
• CD covers
• Stickers
• Name tags
• Gift tags

Decals: Special paper can be used to create decals using a multiple-step process. First, print on the special paper. Then, rub it onto a second peel-off adhesive paper (included in the package) to make a "sandwich." Now place it next to an object (your skin, fingernail, or school notebook), wet the back, and carefully peel away the backing! Keep in mind that if the image you're using for the decal has words in it, you'll need to flip the image horizontally before printing (see page 82). Best uses include:

• Custom temporary tattoos
• Fingernail decals
• School folders and notebooks

Transparent adhesive labels allow the color of the paper beneath to shine through and can add a creative feel to craft projects, such as these homemade gift tags.

Self-adhesive media is available in full-size sheets in addition to the classic pre-cut address label sizes. Full sheets can be used for all sorts of craft projects, including customized book pages.

Magnetic Inkjet Media: This type of printing surface comes with a thin magnetic backing. You can purchase it with pre-cut shapes (including circles), or in full-sized sheets that you cut yourself. Alternately, you can print on regular photo paper, and then apply adhesive-backed magnet stickers. Best uses include:

• Photos for your refrigerator
• Business card magnets
• Emergency contact phone number magnets

Shrink Art Plastics: This type of material is clear plastic. Once you print on it, you place it in the oven for a short period. While heating, it shrinks and becomes thicker. The shrinking process also makes the colors bolder than on most transparent material. If you use a hole puncher to make a hole above the image (or on both sides), it will shrink to a smaller hole that you can attach string or wire to for hanging. Best uses include:

• Earrings
• Necklaces
• Charms
• Ornaments

© Jenni Bidner

A few companies make temporary tattoo and fingernail decals, but with the right paper and an inkjet printer, you can make your own!

Novelty Papers: A few independent manufacturers make very unusual, novelty papers. Some of these unique choices include paper and media with a metallic finish, and even fuzzy papers. (Yes, I said fuzzy papers!) Best uses include:

• Ornaments
• Craft projects
• Gift wrap
• Doll house rugs and accessories

SEVEN FACTORS TO CONSIDER WHEN PURCHASING PAPER

1

Brand: Select a brand you trust. Eastman Kodak Company has been making photo papers for over a century, so it is no wonder that many people select Kodak inkjet papers when they print at home. They're assured of a quality standard that has been upheld for more than a hundred years.

2

Price: Price is a factor, of course, but it is not the only factor, nor the most important one. An inexpensive but inferior paper will end up costing you a lot more when you factor in redo prints, paper jams, sub-standard results, and wasted inks.

3

Category: Papers come in various categories that relate to their intended usage. On one end of the scale are the lightweight "inkjet papers," which are very economical. They are designed for letters, school assignments, and anything where you use a mixture of text and photos. On the other end are the photo quality papers, designed to look and feel like traditional photo lab prints. (See pages 60-75 for more information on paper types.)

4

Thickness: Paper thickness is described in terms of how many pounds a certain number of pages weigh. Therefore, a number like 20 lbs. will be a lot thinner than a higher number like 80 lbs. Light-weight paper will also be a lot cheaper to buy. Foldable letter-weight paper is generally 18 lbs. to 22 lbs. Photo-weight is generally considered to be between 20 lbs. and 24 lbs.

5

Surface: When selecting photo-quality papers, there are three basic types of surfaces: Gloss, Matte, and Semi-Gloss (also called Luster or Semi-Matte). Glossy papers yield the highest detail, clarity, and color saturation. They are a good choice for most photo-quality prints. However, it's really a matter of personal preference and the type of image you're printing. Matte papers lose a bit of detail and clarity, but this often results in more pleasing portraits because it makes for smoother looking skin tones. The surface itself also helps to hide fingerprint smudges from enthusiastic handling. Semi-Gloss is somewhere in between Glossy and Matte, in terms of both looks and pros and cons.

6

Paper Size: Your options for paper sizes depend on your printer's capabilities, but you can usually select perforated or un-perforated paper at a given size for your printing needs. What size are you printing at? Do you want traditional 4 x 6-inch prints (A6)? Depending on your printers capability, you could make single-sheet borderless 4 x 6-inch prints, single-sheet prints with borders, print two per sheet on perforated 8 x 10-inch sheets (A4), or two per un-perforated sheet and hand trim them later.

7

Novelty Options: If you have a fancy project in mind, check and see if there is a specialty paper that will make it easier, such as pre-scored greeting card papers with matching envelopes (scoring allows them to fold cleanly).

Selecting a Paper Surface

Glossy / Semi-Gloss / Matte

Pros
Glossy shows the most vivid colors and the most intricate details. If you can't decide between Glossy and Matte, you're a good candidate for Semi-Gloss! Matte papers hide fingerprints and smudges the best, so they are a great choice for prints that will be handled a lot. Slightly less detail delivers smoother skin tones.

Cons
The shiny surface of Glossy paper is very reflective making viewing difficult under certain lighting. Fingerprints also show up more on this surface. With Matte papers you will see a slight loss of detail and clarity.

Top Three Solutions for Bad Prints

If you're getting poor results, there are a few ways you can make quick improvements:

Check Your Paper: Use paper made specifically for inkjet printers from a reputable company.

Check Your Inks: Use the brand of ink made for your printer. Cheap mail-order brands may not be worth the savings if the result is prints with weaker colors or unwanted color casts.

Check Your Image Size or Resolution: For good prints, you'll need an image resolution of at least 150 ppi (preferably 200 ppi) at the size you're printing at. In other words, for every inch of the image you're using to make a print, there must be over 150 pixels (and preferably more) for good results. Anything less, and the print might not look good. (See page 41 for more about image resolution and printer resolution.) If you're not sure of your image resolution, you can check it in most image-processing software by using the Image Size (or similarly named) command. It will list a size in inches at a particular ppi, or in pixels (by width and height).

Kodak Inkjet Papers

Eastman Kodak Company offers a wide range of quality inkjet papers for a variety of applications. They range from Ultima papers that offer the greatest longevity and highest photo quality, to economical options for everyday printing projects. All of the papers (including the *Kodak Professional* line) have universal printer capability, so they can be used with any desktop inkjet photo printer. When combined with *Kodak EasyShare* software, they insure great one-touch results.

Hint: For the best results with most printers, match the ink brand with the printer manufacturer. Independent manufacturer's inks will often yield less-saturated colors, and even color casts in your images. If your printer accepts archival or long-life inks, use them when you are printing pictures for your album, your wall, or any other long-term use.

KODAK PAPER CHART

Paper Type:

Kodak Professional Inkjet Photo Paper

Description:

Kodak Professional Inkjet Photo Paper is designed for professional, studio-quality prints. Like all *Kodak* inkjet papers, it is universally compatible and will work with all inkjet photo printers.

Details:

When used with pigment-based inkjet printers, it delivers a longevity similar to *Kodak* Ultima papers. It has a photographic resin-coated base for a true photographic look and feel, and comes in either Lustre or Gloss finish. Advanced color profiles are available for professional photo printers using *Kodak Professional* Inkjet Photo Papers, thereby providing exceptional color accuracy and shadow detail.

Best Usages:

- Professional quality prints on resin-coated photo paper base

- Large prints for wall display

- Huge panoramas with printers able to accept paper rolls

- Weight : 255 g/m

- Thickness: 9 mil

- Brightness: 94

- Gloss finish comes in 8.5 x11 inch (A4) and 13 x 19 inch (B3) cut sizes, and rolls in 10 inch (25.4 cm), 16 inch (40.6 cm), and 20 inch (50.8 cm) widths.

- Lustre Finish comes in 8.5 x 11 inch (A3) and 13 x 19 inch (B3) cut sizes, and rolls in 10 inch (25.4 cm), 16 inch (40.6 cm), and 20 inch (50.8 cm) widths.

Paper Type:

Kodak Ultima Picture Paper

Description: *Kodak* Ultima Picture Paper features breakthrough *Kodak ColorLast* technology. It is their highest quality, longest lasting inkjet photo paper. *Kodak* Ultima paper shields photos from the key factors that lead to fading: light, air pollution, moisture, and heat. It uses the same paper base as the industry-acclaimed *Kodak Royal* Photographic Paper.

Best Usages:

- Albuming and scrapbooking

- Showcasing and framing your most treasured photos

- Creating inkjet prints with the look and feel of conventional photographic prints

- Weight : 270 g

- Thickness: 10 mil

- Brightness: 92

- High Gloss finish comes in 4 x 6 inch (A6), 5 x 7 inch (A5), and 8.5 x 11 inch (A4) sizes

- Satin finish come in 4 x 6 inch (A6) and 8.5 x 11 inch (A4) sizes

Paper Type:

Kodak Anytime
Picture Paper

Description:

Kodak Anytime Picture Paper is an economical way to share your magical moments. This lightweight paper makes printing bright-colored photos fun and affordable! Plus, *Kodak* Anytime Picture Paper dries instantly, so you can be as spontaneous as you like.

Best Usages:

- Sharing fun moments
- Everyday pictures
- School projects * Weight : 165 g
- Thickness: 6 mil
- Brightness: 94
- Comes in 4 x 6 inch (A6) and 8.5 x 11 inch (A4) sizes.

Paper Type:

Kodak Premium
Picture Paper

Description:

Photos printed on *Kodak* Premium Picture Paper come to life with bright color and sharp detail that's sure to impress! This hefty paper is available in High Gloss and Satin finishes, so your pictures look and feel like a true photograph.

Best Usages:

- Albuming and scrapbooking
- Sharing special memories like vacations or holidays
- Making framed gifts
- Sharing your snapshots * Weight : 270 g
- Thickness: 8 mil
- Brightness: 97
- High Gloss finish comes in 4 x 6 inch (A6), 8.5 x 11 inch (A4), and 11 x 17 inch (A3) sizes.
- Satin finish comes in 4 x 6 inch (A6) and 8.5 x 11 inch (A4) sizes.

KODAK PAPER CHART

Paper Type:

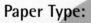

Kodak Picture Paper

Description:

Kodak Picture Paper respects your need for creative freedom. This medium-weight paper is coated on both sides, so it's great for colorful photo projects and it's very forgiving. Made a mistake? No worries—just turn it over and try it again!

Best Usages:

- Two-sided printing projects
- Photo craft projects
- Experimenting with creative photo effects
- Weight : 190 g
- Thickness: 8 mil (Matte), 7 mil (Soft Gloss)
- Brightness: 96
- Soft Gloss finish comes in 4 x 6 inch (A6) and 8.5 x 11 inch (A4) sizes.
- Matte finish comes in 8.5 x 11 inches (A4).

Paper Type:

Kodak
Matte Paper

Description:

Kodak Matte Paper is designed with a smooth matte finish to minimize smudging, glare, and fingerprints. It can be printed on both sides for two-sided applications and for economy, and is available in both heavy weight and medium weight.

Best Usages:

- Sharing fun moments
- Scrapbooking
- Frequently handled prints
- Weight : 165 g (heavy), 130 g (medium)
- Thickness: 8 mil (heavy), 6 mil (medium)
- Brightness: N/A
- Comes in size 8.5 x 11 inches (A4).

Paper Type:

Kodak Bright White
Inkjet Paper

Description:

Kodak Bright White Inkjet Paper is the most versatile of
all *Kodak* papers. It can be used on any inkjet printer,
laser printers, and copier machines.

Best Usages:

• Everyday documents and general projects for home
 and office

• Economical letters, drafts, and color-rich documents

• Weight : 90 g

• Thickness: 5 mil

• Brightness: 110+

• Comes in size 8.5 x 11 inches (A4).

Pre-Printing Image Improvements

> *"A few minutes working with image-processing software can turn an average snapshot into an outstanding photograph."*

Don't panic! We're not talking dozens of hours at the computer and hundreds of dollars spent on software. In just a few minutes, you can use free or inexpensive software to transform an ordinary picture into something wonderful. Cropping can quickly eliminate distracting backgrounds. Brightness and contrast corrections and simple changes in the overall color can add snap to many pictures. Some software programs offer incredibly simple one-click red-eye reduction. And for the more seasoned computer artists, the Stamp and Clone tools allow you to quickly improve backgrounds, eliminate blemishes, and otherwise improve the image before sending it to the printer.

Minor damage to historic images can easily be corrected using image-processing software.

© Jenni Bidner

Old, faded photos can be automatically restored with *Kodak EasyShare* software.

Photo courtesy of Jenni Bidner

Picture-Viewing Software vs. Image-Processing Software

Most computer operating systems come with picture-viewing software. This type of software allows you to open and view pictures, but not much else. To get the most out of your printer (and out of the whole photography experience), you'll want to invest in an image-processing software program.

Image-processing programs allow you to improve, alter, and manipulate your digital pictures. Popular programs include *Kodak EasyShare*, Adobe Photoshop Elements, MGI PhotoSuite, Microsoft Picture It, Scansoft PhotoFactory, and Ulead PhotoImpact. *Kodak EasyShare* software is free, and offers simple corrections in addition to the primary functions of aiding in the printing, sharing, and cataloging of your digital pictures.

In the next few pages, we'll go over the "Top 16" most important image-processing software functions. However, before you start working on a picture, be sure to use the Save As function to create a new version of the original photo using a different file name. Otherwise, once you start "playing" with the image, if you accidentally click on Save instead of Save As, you will replace (overwrite) the original, thereby losing the unaltered version forever! So before you do anything, select Save As and create a new copy of the file with a different name. For example, if your image file is called RobSwim, the newer file can be called RobSwim2, or RobSwimEDIT.

Start with a Plan

Before you start retouching, try to come up with a plan. First fix the brightness, contrast, or color, because this will make the biggest, fastest improvement. You can use the Auto Levels (or similarly named command) to do this, but if that doesn't look perfect, use the Undo command and then work the controls manually. Removing distracting elements by cropping or using the Stamp or Clone tools is the next best step.

image 1

© Janet Anagnos

The original picture (image 1) started out okay; auto enhancing made it worse (image 2); manual corrections to color, contrast, and brightness improved it (image 3); cropping eliminated the distracting background and focused the viewer's attention on the important part of the photo (image 4 and image 5).

image 2

image 3

image 4

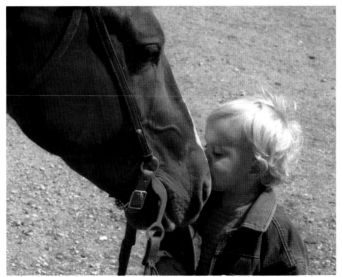

image 5

© Jenni Bidner

In addition to quarter turn or half turn rotation, some software lets you straighten a crooked image or tilt an image for affect using the Arbitrary Rotation (or similarly named) command.

① Rotate

You may need to rotate your picture if it shows up on your computer sideways or upside-down. You can usually rotate your image in quarter turns (90°) clockwise or counter-clockwise, as well as in half turns (180°). Some more advanced softwares also allow you to select arbitrary rotation to straighten an image if you accidentally shot it slightly askew or crooked.

② Magnify

Your software will have a magnify or zoom option, usually accessed through an icon that looks like a magnifying glass, or under the View or Zoom command tab. This is an important feature because it allows you to take a look at the detail in the picture without permanently altering the picture (like cropping would do—see number 3 below). This is a handy way to check whether a picture is in focus, or to make sure someone's expression is nice. is also good to use when you are making detailed software corrections, such as with the Stamp or Clone tools.

③ Crop

One of the quickest ways to improve your photograph to crop out unimportant parts of the picture. You'll be amazed at how just trimming off an edge can dramatically improve the picture. This technique helps draw the viewer's eye and attention to the main subject. You can also use cropping to eliminate bad or boring backgrounds, or to turn a horizontal picture into a vertical one. Extreme cropping can create artistic renditions of ordinary subjects, but be careful! When you crop an image, you are "throwing away" pixels, and the cropped version will have a lower resolution than the original. Low-resolution pictures cannot be successfully printed as well as high-resolution pictures can. So always shoot or scan at the highest resolution your hardware allows you think you may want to crop the image.

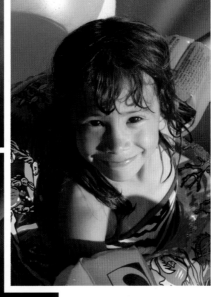

© Jenni Bidner

Cropping your images is one of the quickest ways to improve your photographs. Take a few seconds to look at each digital picture before you print it. Ask yourself if the image includes anything extraneous, unimportant, or distracting that you can crop out. If the answer is yes, then crop it!

4 Red-Eye Correction

Everyone has seen photographs where the subject's eyes appear red. The red-eye reduction flash mode on some point-and-shoot cameras will reduce occurrences of this effect by firing a pre-flash or shining a bright lamp before taking the picture. Many people find this light and the accompanying delay annoying, so they don't use it. In that case, you'll want to use the simple red-eye functions available with many image-processing programs that enable you to click on the eyes in the picture to quickly and automatically neutralize the red coloring.

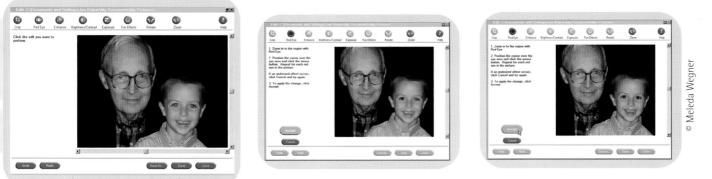

© Meleda Wegner

Many image-processing software programs, including *Kodak EasyShare*, offer simple one-click red-eye reduction.

© Jenni Bidner

Image-processing programs usually have an Auto Enhance or Auto Levels one-touch optimizing feature. For certain photos, it works great. But, like any automatic function, it won't work for every situation. You can always select Undo if you don't like the results.

⑤ Flip

This function allows you to create a mirror image of your original picture. It can be flipped along the horizontal or vertical axis. The Flip command is useful when printing on image transfer and decal papers because, after printing when the image is transferred, it is reversed. For example if you reverse a picture with type before you print it, it will look right (and the text will read correctly) when it is finally transferred to a t-shirt. (See page 65 for more about transfer paper.)

⑥ Auto Correction

Most image-processing software programs offer an Auto Levels (or similarly named) function that will automatically correct the color, contrast, and other aspects of your digital photograph. For example, snow scenes usually come out bluish because the camera is fooled by the whiteness of the scene and accidentally underexposes the photo. Auto Levels will usually fix this for you. If your software program has a preview option, you'll be able to see the suggested changes before committing to them.

No automatic tool is perfect for every picture. Automatic correction doesn't always improve the image, and it can sometimes make it worse! Try it out to see its effects, then select Undo if you don't think it is an improvement.

⑦ Brightness and Contrast

You can quickly improve a picture by brightening or darkening it with the Brightness control. You can also increase or decrease the contrast. Increasing the overall contrast makes the shadows darker and the highlights lighter. This can sometimes help make a slightly blurred image look sharper.

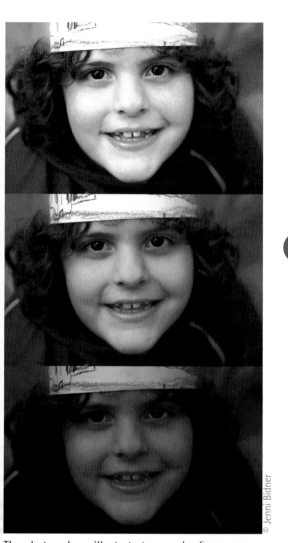

© Jenni Bidner

The photos above illustrate too much of an increase in brightness and contrast (top); just right (middle); and too much of a decrease in brightness and contrast (bottom).

Dodge and Burn

The overall brightness control in most programs affects the entire image. However, there will be times when you want to lighten or darken only a particular part of the picture. For example, you can use the Dodge tool on a face to lighten it, or use the Burn tool on a background object to make it darker and less distracting.

For the best results, adjust the size of the Dodge or Burn tool (usually by selecting a brush size). Then, select the opacity or strength level—start with a low number. It's better to take several strokes at 10% opacity than one strong stroke at 100% opacity; it may take more time to get to the lighter or darker effect that you want, but the result will be smoother and much more natural looking.

In this example, the Dodge tool was used to lighten the shadow side of the man's face. The original photo is on the left, and the post-dodging version is on the right.

Photo courtesy of Jenni Bidner

Ⓐ Color Correction

It's not uncommon for photographs to have an unwanted color cast. This means that the whole picture has an overall, unnatural color tint to it. You may not even realize the image has a color cast until you see it side by side with a corrected or improved version. If your image-processing software has a Variations, or similarly named command, this offers you a quick way to check the color in your image. First, it shows your original, then versions with more red, green, blue, cyan, yellow, and magenta, as well as lighter and darker versions. Click on the one you like best and you're ready to go. Other software programs have sliding bars you can move to adjust the color.

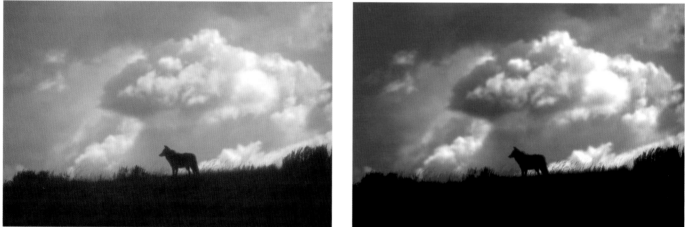

© Jenni Bidner

Your color changes need not be subtle or purely for "correction." The sky in this coyote picture was turned extra blue for fun. Likewise, you can turn a person "green with envy" or make them truly "blue."

The Brush Tool

Image-processing programs have controls called "tools" that help you make your desired corrections and improvements. The Brush tool is one of the most important because this controls the extent to which you apply the various changes. The Brush tool can be changed in many ways, such as size, opacity, and hardness. In the case of a Paintbrush tool, it can be adjusted in terms of what type of paint effect you're looking for—oil paint, watercolor, spray paint/graffiti, and more. Read the instruction manual or check the Help menu to find out all of your program's Brush tool capabilities.

Ⓑ Color Modes

Most image-processing programs allow you to instantly change your color picture into various other color modes, such as black-and-white, sepia, posterized, cartoon, saturated, duotone, and more. Note that when most people refer to a "black-and-white photo," they really mean one made up of many shades of gray, not just black and white. The name of your program's "black-and-white" mode is probably "grayscale."

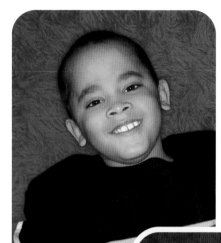

Adding or Changing Color

Color can be added or changed in your digital picture. You can "paint" over sections with new colors, or selectively alter the color, or changee the color of the background.

Sharpen

The Sharpen tool cannot work miracles, but it can help to improve the appearance of slightly unsharp images. Be careful to use a light hand, because overly sharpened pictures end up looking grainy and fake. Increasing the contrast can also help create the appearance of sharpness. However, it's always best to try to start with the sharpest possible picture straight out of the camera.

Color can be selectively changed in advanced image-processing programs. This is especially useful for altering backgrounds or hair color.

© Eric Bean

Monitor Calibration for Advanced Color

The serious photographer may want to take ultimate control over their printing by practicing color management techniques. In its simplest form, this means making sure your monitor is properly calibrated. Check the Control Panel or Utilities section of your operating system for a Monitor Calibration or Display Calibration function, then follow the simple instructions. (Use the Search or Find feature if it is not readily apparent.)

Those of you with professional aspirations may advance to the point of an external calibrator. This is a small piece of hardware that attaches to the monitor and, when combined with its accompanying software, reads the color on the screen. The software then helps you calibrate the monitor so it matches your printer, the goal being that what you see on the screen in terms of color and contrast is as close as possible to what comes out of the printer on the first try.

Fun with Color

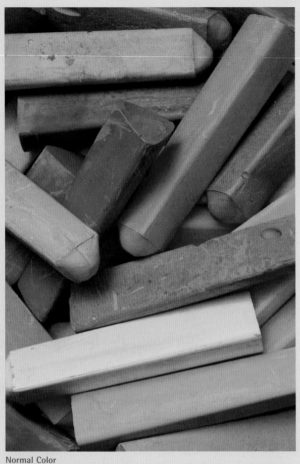

Normal Color

Grayscale ("black-and-white") color mode

Sepia (sometimes called "antique") color mode

Lineart (sometimes called "black-and-white") color mode

Posterized (6 levels)

Color balance shift (plus magenta, or minus green)

Increase color saturation

Selective color change (red chalk changed to purple)

Selective desaturation (color removed from certain places)

Clone and Stamp

These are great tools for quickly retouching your pictures. The concept is that you "clone" one part of the picture to pick up color, then "stamp" it down elsewhere. You can quickly hide a facial blemish in a portrait by covering it with nearby unblemished skin. Likewise, trash in the grass in a scenic picture can be covered by using the Clone tool on nearby grass. Random textured areas, such as grass or bushes, are often the easiest to work with. Select a new sampling area (new "ink") often to avoid creating an unwanted pattern when you do this.

Adding Text

You can add text to your pictures in most image-processing programs. Often, the command for adding text is accessed by clicking on the icon of a square with the letter "A" or "T" inside, or sometimes the word "Font." The text is placed in a text box that can be moved around or resized. The typed letters come in different fonts, and each font has a different look. Your computer should have a selection to choose from. You can also adjust their point size. The larger the point size, the larger the size of the letters. You can also select color from a palette of choices, and sometimes you can even select shade (light to dark).

In general, dark letters are easier to read against light backgrounds, and light letters are easier to read against dark backgrounds. Conflicting colors (like red on yellow) might be bold, but they can be hard to read. Some software programs allow you to warp, arc, and even twist the letters to create interesting shapes out of the words. Don't overlook the visual power of the letters themselves. Certainly, words have meaning in terms of what they say, but they can also help the design.

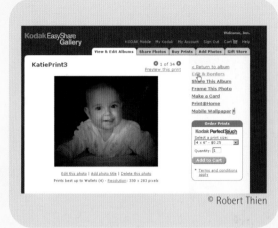

© Robert Thien

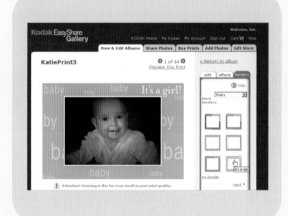

Online photofinishers, such as *Kodak EasyShare* Gallery, allow you to click on border options and preview your pictures inside them. These pictures with borders can then be printed or turned into greeting cards, calendars and novelty items.

⑮ Edges and Borders

A picture placed on your wall that is in a carefully chosen frame can look stunning. Do it right, and you can enhance the picture. Do it wrong, and the frame becomes more important than the picture and robs it of impact. Frames are also important in the world of digital photography, but here we call them "edges" or "borders." Selecting the right border is easy in image-processing software because you can compare different effects and pick which works best for you. Some software simply gives you white, black, or colored edges of different thickness. Other software offers intricate designs and themed frames, such as congratulations, thank you, or holiday imagery. The frame then becomes a part of the picture and is included as part of the print.

© Jenni Bidner

image 1

It is sometimes surprising how good (or bad) a picture looks inside a certain border. Often it is a matter of picking appropriate colors. In this example, the parents loved this summertime picture and wanted to use it as a holiday card. However, the green background was too "summery" (image 1) and did not look good against the purple background. Instead, they changed the picture to sepia before adding the border. The result was a more harmonious card (image 2). Both were made in less than a minute (including the sepia conversion) at a *Kodak* Picture Maker kiosk in a grocery store.

image 2

16 Stitching Panoramas

Many image-processing software programs now offer
Stitching or Panorama tools. Take a series of photos that
capture the scene in front of you, and then the software
will automatically stitch them together for a seamless
360° circle or an extra-long panoramic effect. For the best
results, overlap the pictures and take care to keep the
camera level for all pictures in the series—the easiest way
to do this is by using a tripod.

© Rob Sheppard

Black-and-White Images

Walk into any photography gallery or museum, and you will find that much (if not most) of the collection is black-and-white photography. It's not really surprising; artists want to show us a view of the world that we don't normally see. Since we see the world in all its bright colors on a daily basis, a picture stripped of color instantly offers us an inherently new view. This allows both the photographer and the viewer of the image to concentrate on tones, textures, shadows, and expressions.

It's easier to create black-and-white images than you'd think. In the old days, you had to shoot with silver-halide films, then develop and print them in a darkroom. Even modern chromogenic (dye-based films) black-and-white films are only marginally easier because they can be developed and printed in any one-hour photo lab. However, by far the easiest method is digital black-and-white photography! Some digital cameras offer a black-and-white shooting mode, but it is just as easy to use an image-processing program to instantly convert any digital color image into black and white with one click. If you can't decide whether color or black and white looks better, don't worry—just save both!

More Than Just Black and White

It is important to note that what we call a "black-and-white" image is really an image made up of over 250 tones of white, black, and gray—technically referred to as "grayscale." You can also use image-processing programs to add a color cast to these gray tones in order to create warm, antique looking version, often called sepia.

One way to create a sepia-colored image from a color photo is to use the Mode (or similarly named) function to convert the color photo to grayscale. This strips the colors out. Then use the Mode function again to convert the image back to RGB color. Using the Color Balance (or similar) function, you can add color. I like to add bluish tones for the look of a historic cyanotype print, or reddish brown tones for an antique sepia print look, but you can use whatever color you want! After adding the color tone, you may need to tweak the contrast and brightness to optimize your results before printing.

© Kevin Kopp

Glossary

aperture
The opening in the lens that allows light to enter the camera. Aperture is usually described as an f/number. The higher the f/number, the smaller the aperture; and the lower the f/number, the larger the aperture.

automatic exposure
When the camera measures light and makes the adjustments necessary to create proper image density on sensitized media.

backup
A copy of a file or program made to ensure that, if the original is lost or damaged, the necessary information is still intact.

bounce light
Light that reflects off of another surface before illuminating the subject.

buffer
Temporarily stores data so that other programs, on the camera or the computer, can continue to run while data is in transition.

built-in flash
A flash that is permanently attached to the camera body. The built-in flash will pop up and fire in low-light situations when using the camera's automated exposure settings.

card reader
Device that connects to your computer and enables quick and easy download of images from memory card to computer.

close-up
A general term used to describe an image created by closely focusing on a subject. Often involves the use of special lenses or extension tubes. Also, an automated exposure setting that automatically selects a large aperture (not available with all cameras).

CMYK mode
Cyan, magenta, yellow, and black. This mode is typically used in image-editing applications when preparing an image for printing.

color cast
A colored hue over the image often caused by improper lighting or incorrect white balance settings. Can be produced intentionally for creative effect.

compression
Method of reducing file size through removal of redundant data, as with the JPEG file format.

contrast
The difference between two or more tones in terms of luminance, density, or darkness.

cropping
The process of extracting a portion of the image area. If this portion of the image is enlarged, resolution is subsequently lowered.

depth of field
The image space in front of and behind the plane of focus that appears acceptably sharp in the photograph.

digital zoom
The cropping of the image at the sensor to create the effect of a telephoto zoom lens. The camera interpolates the image to the original resolution. However, the result is not as sharp as an image created with an optical zoom lens because the cropping of the image reduced the available sensor resolution.

download
The transfer of data from one device to another, such as from camera to computer or computer to printer.

dpi
Dots per inch. Used to define the resolution of a printer, this term refers to the number of dots of ink that a printer can lay down in an inch.

D-SLR
A digital single-lens-reflex camera. See also, SLR.

dye sublimation printer
Creates color on the printed page by vaporizing inks that then solidify on the page.

electronic flash
A device with a glass or plastic tube filled with gas that, when electrified, creates an intense flash of light. Also called a strobe. Unlike a flash bulb, it is reusable.

exposure
When light enters the camera and reacts with the sensitized medium. The term can also refer to the amount of light that strikes the light sensitive medium.

file format
The form in which digital images are stored and recorded, e.g., JPEG, RAW, TIFF, etc.

firmware
Software that is permanently incorporated into a hardware chip. All computer-based equipment, including digital cameras, use firmware of some kind.

focal length
When the lens is focused on infinity, it is the distance from the optical center of the lens to the focal plane.

focus
An optimum sharpness or image clarity that occurs when a lens creates a sharp image by converging light rays to specific points at the focal plane. The word also refers to the act of adjusting the lens to achieve optimal image sharpness.

f/stop
The size of the aperture or diaphragm opening of a lens, also referred to as f/number or stop. The term stands for the ratio of the focal length (f) of the lens to the width of its aperture open-

ing. (f/1.4 = wide opening and f/22 = narrow opening.) Each stop up (lower f/number) doubles the amount of light reaching the sensitized medium. Each stop down (higher f/number) halves the amount of light reaching the sensitized medium.

full-frame sensor
A sensor in a digital camera that has the same dimensions as a 35mm film frame (24 x 36 mm).

GB
See gigabyte.

gigabyte
Just over one billion bytes.

grayscale
A successive series of tones ranging between black and white, which have no color.

hard drive
A contained storage unit made up of magnetically sensitive disks.

histogram
A graphic representation of image tones.

hot shoe
An electronically connected flash mount on the camera body. It enables direct connection between the camera and an external flash, and synchronizes the shutter release with the firing of the flash.

interpolation
Process used to increase image resolution by creating new pixels based on existing pixels. The software intelligently looks at existing pixels and creates new pixels to fill the gaps and achieve a higher resolution.

ISO
From ISOS (Greek for equal), a term for industry standards from the International Organization for Standardization. When an ISO number is applied to film, it indicates the relative light sensitivity of the recording

medium. Digital sensors use film ISO equivalents, which are based on enhancing the data stream or boosting the signal.

JPEG
Joint Photographic Experts Group. This is a lossy compression file format that works with any computer and photo software. JPEG examines an image for redundant information and then removes it. It is a variable compression format because the amount of leftover data depends on the detail in the photo and the amount of compression. At low compression/high quality, the loss of data has a negligible effect on the photo. However, JPEG should not be used as a working format—the file should be reopened and saved in a format such as TIFF, which does not compress the image.

LCD
Liquid Crystal Display, which is a flat screen with two clear polarizing sheets on either side of a liquid crystal solution. When activated by an electric current, the LCD causes the crystals to either pass through or block light in order to create a colored image display.

lens
A piece of optical glass on the front of a camera that has been precisely calibrated to allow focus.

lossy
Image compression in which data is lost and, thereby, image quality is lessened. This means that the greater the compression, the lesser the image quality.

MB
See megabyte.

megabit
One million bits of data. See also, bit.

megabyte
Just over one million bytes.

megapixel
A million pixels.

memory
The storage capacity of a hard drive or other recording media.

memory card
A solid state removable storage medium used in digital devices. They can store still images, moving images, or sound, as well as related file data. There are several different types, including CompactFlash, SmartMedia, and xD, or Sony's proprietary Memory Stick, to name a few. Individual card capacity is limited by available storage as well as by the size of the recorded data (determined by factors such as image resolution and file format). See also, CompactFlash (CF) card, file format.

menu
A listing of features, functions, or options displayed on a screen that can be selected and activated by the user.

mode
Specified operating conditions of the camera or software program.

noise
The digital equivalent of grain. It is often caused by a number of different factors, such as a high ISO setting, heat, sensor design, etc. Though usually undesirable, it may be added for creative effect using an image-processing program. See also, chrominance noise and luminance.

overexposed
When too much light is recorded with the image, causing the photo to be too light in tone.

pixel
Derived from picture element. A pixel is the base component of a digital image. Every individual pixel can have a distinct color and tone.

plug-in
Third-party software created to augment an existing software program.

pre-flashes
A series of short duration, low intensity flash pulses emitted by a flash unit immediately prior to the shutter opening. These flashes help the TTL light meter assess the reflectivity of the subject. See also, TTL.

RAW
An image file format that has little or no internal processing applied by the camera. It contains 12-bit color information, a wider range of data than 8-bit formats such as JPEG.

RAW+JPEG
An image file format that records two files per capture; one RAW file and one JPEG file.

red-eye reduction
A feature that causes the flash to emit a brief pulse of light just before the main flash fires. This helps to reduce the effect of retinal reflection.

resolution
The amount of data available for an image as applied to image size. It is expressed in pixels or megapixels, or sometimes as lines per inch on a monitor or dots per inch on a printed image.

RGB mode
Red, Green, and Blue. This is the color model most commonly used to display color images on video systems, film recorders, and computer monitors. It displays all visible colors as combinations of red, green, and blue. RGB mode is the most common color mode for viewing and working with digital files onscreen.

saturation
The intensity or richness of a hue or color.

sharp
A term used to describe the quality of an image as clear, crisp, and perfectly focused, as opposed to fuzzy, obscure, or unfocused.

shutter
The apparatus that controls the amount of time during which light is allowed to reach the sensitized medium.

SLR
Single-lens reflex. A camera with a mirror that reflects the image entering the lens through a pentaprism or pentamirror onto the viewfinder screen. When you take the picture, the mirror reflexes out of the way, the focal plane shutter opens, and the image is recorded.

small-format sensor
In a digital camera, this sensor is physically smaller than a 35mm frame of film. The result is that standard 35mm focal lengths act like longer lenses because the sensor sees an angle of view smaller than that of the lens.

stop
See f/stop.

telephoto effect
When objects in an image appear closer than they really are through the use of a telephoto lens.

telephoto lens
A lens with a long focal length that enlarges the subject and produces a narrower angle of view than you would see with your eyes.

thumbnail
A miniaturized representation of an image file.

TIFF
Tagged Image File Format. This popular digital format uses lossless compression.

tripod
A three-legged stand that stabilizes the camera and eliminates camera shake caused by body movement or vibration. Tripods are usually adjustable for height and angle.

TTL
Through-the-Lens, i.e. TTL metering.

USB
Universal Serial Bus. This interface standard allows outlying accessories to be plugged and unplugged from the computer while it is turned on. USB 2.0 enables high-speed data transfer.

viewfinder screen
The ground glass surface on which you view your image.

wide-angle lens
A lens that produces a greater angle of view than you would see with your eyes, often causing the image to appear stretched. See also, short lens.

Wi-Fi
Wireless Fidelity. A technology that allows for wireless networking between one Wi-Fi compatible product and another.

zoom lens
A lens that can be adjusted to cover a wide range of focal lengths.

Index

Other Kodak Titles by Lark Books